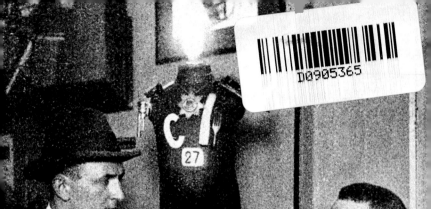

# Die Kunst ist tot

## Es lebe die neue Maschinenkunst

# TATLINS

# Sperren Sie endlich Ihren Kopf auf!

Nieder die Kunst

**Machen Sie ihn frei für die Forderungen der Zeit!**

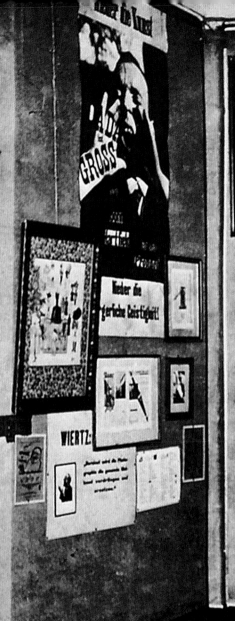

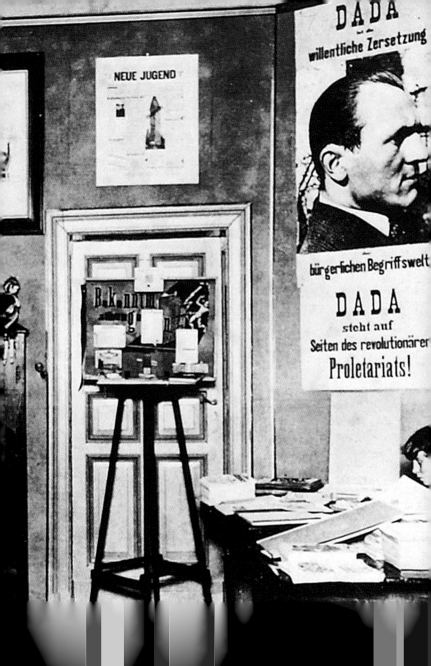

# CONTENTS

# DADA
## THE REVOLT OF ART

Marc Dachy

DISCOVERIES®
ABRAMS, NEW YORK

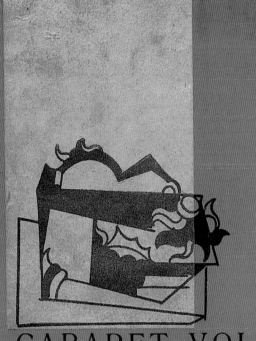

# CABARET VOLTAIRE

# Futurisme Cubism
# Expressionism

GUILLAUME APOLLINAIRE, HANS ARP, HUGO BALL, FRANCESCO CANGIULLO, BLAISE CENDR
EMMY HENNINGS, JACOB VAN HODDIS, RICHARD HUELSENBECK, MARCEL JANCO, WASS
KANDINSKY, F. T. MARINETTI, L. MODEGLIANI, M. OPPENHEIMER, PABLO PICASSO, O VAN R
M. SLODKI, TRISTAN TZARA

PRIX: broché 2 frs., relié 3 frs.

Emerging in 1916 from the melting pot of abstract painting and avant-garde poetry, Dada was a crisis in art, a leap outside the ranks of the "isms," a complete insurrection. Reinventing the mechanisms of creation and thought, a group of young artists fundamentally changed the world's conception of art. The incandescence and integrity of this individualist revolt were to become the yardstick for all avant-garde art in the future.

CHAPTER 1

# DADALAND

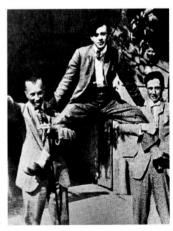

**Left:** Cover of *Cabaret Voltaire,* May 1916, woodcut by Marcel Janco. By combining Enlightenment philosophy with the spontaneity of a cabaret, Hugo Ball and his friends declared their independence from the war and their determination that language and art must no longer comply in the general alienation that had caused it.
**Right:** Carried aloft in triumph by Jean Arp and Hans Richter is Tristan Tzara, who gave this revolt its name: Dada.

The birth of Dada was something like a legend: a group of friends who were young artists, a cabaret, a magazine, then a collection, some more magazines, and several exhibits. All this took place in 1915 in Zurich, a peaceful city on the banks of the Limmat. The First World War was raging all around, but standing apart was Zurich, or "Dadaland," as Jean Arp jokingly called it in an acerbic account given in 1948: "In Zurich, we had no interest in the abattoirs of the World War, and devoted ourselves to fine art. While the thunder of artillery rumbled away in the distance, we were putting together collages, reciting, writing verse, and singing with all our hearts. We were looking for an elementary type of art that we thought would save mankind from the raging madness of those times. We aspired to a new order that could re-establish the balance between heaven and hell. This art quickly became the object of general reprobation. It was hardly surprising that the 'bandits' could not understand us. Their puerile obsession with authoritarianism demands that even art should serve to stupefy mankind."

From the name Dadaland, it might seem that, for the Dadaists, Zurich in neutral Switzerland was just a haven of retreat. However, art and verse-writing were no longer innocent activities in a world devastated by

le géant blanc lé
preux du paysag

le sel se groupe en constellatio
d'oiseaux sur la tumeur de ouat

dans ses poumons les astéries
les punaises se balancent
les microbes se cristallisent €
palmiers de muscles balançoir€
bonjour sans cigarette tzantzant₂
ganga
bouzdouc zdouc nfoùnfa mbaa
mbaah nfoùnfa
macrocystis perifera embrasser l€
bateaux chirurgien des bateau
₂atrice humide propre
₂₂se des lumières éclatantes
₂ bateaux    nfoùnfa    nfoùn
₂nfa
₂ui enfonce les cierges dans l€
₂reilles  gangànfah  hélicon
₂oxeur sur le balcon le violc
₂e l'hôtel en baobabs de flamm€
₂s flammes se développent €
₂ation d'éponges

₂mes sont des épong€
₂t frappez
₂s ₂ontent comme
₂à
₂es vers les steppes d
₂ hazard vers les ca

**Left:** Tristan Tzara was nineteen years old; he was a poet to the core, a dazzling intelligence, and the conscience of his time, who "opened his heart to creation," "to the intimate vibrations of the last cell of a mathematical-brain-god." As a poet and theorist he unleashed a verbal revolution.

the barbarity of a terrible war; Dada embodied a new generation of artists and a radically new type of art, whose revolutionary nature in such a context inevitably had to be seen not just as an aesthetic stance, but as a political one as well. Its aim was to free art from its role as the stupefying

### Die schwalbenhode

4.

Tapa tapa tapa
Pata pata
Maurulam katapultilem i lamm
Haba habs tapa
Mesopotaminem masculini
Bosco & belachini
Haba habs tapa
Woge du welle
Haha haha

ARP

veneer on a society whose values no longer could be sustained, and whose collapse had shown that it was obsolete. It was time for a completely fresh start. Far from aspiring to become the most advanced form of modern art, Dada aimed to accelerate a crisis, and this at the very heart of abstraction, which itself was already highly critical of other forms of art. "Dada is the ensign of abstraction," proclaimed Tzara, who in other respects was always suspicious of the idea of modernity or "modern" art.

### What Was Dada?

Dada was a word, a rallying symbol, an intentionally derisory anti-label. As a provocative slogan it wrong-footed the critics, who habitually pinned pejorative labels on new tendencies, such as Cubism. The tone was set: the Dadaists were not aiming to win over the critics, but to mock them. Duchamp called them "critiques dard" (a pun on *critiques d'art, dard*

Poetic writing was a liberation from the conditioning of compromised language. Tzara contrasted the creative artist with the "foul" man who destroys. Arp did the wood engraving for the cover of Tzara's *Vingt-Cinq poèmes* (Twenty-five poems). Arp also wrote poetry; in *Die Schwalbenhode* (The swallow's testicle, *above left*); his penchant for sonorities is reminiscent of Tzara's passion for African poetry and Ball's abstract poetry.

meaning "dart"), Schwitters ironically referred to them as "messieurs les criquicques," and Raoul Hausmann caricatured them in a collage. By adopting this polemical relationship with the critics (the only one it could adopt), Dada won a head start that it never lost.

The Dada experiment in Zurich, or the Dada Movement, as it became officially known, transformed art, reinventing every discipline from within. An inherited culture that had now become unacceptable was replaced by a new inventiveness and a direct relationship between the artist and his art—as opposed to the art that until then had been imposed by social constraints. Dada demonstrated that a society that had lost respect was no longer in a position to demand that the artist adhere to its aesthetic and ideological values. The bourgeois idea of beauty had become ridiculous. Poetry was now abstract and based on sound, acting as an antidote to the standardization of language by journalism. Rather than focusing on representation, painters now worked with their material for its own sake in terms of its color, form, and structure, and felt liberated from the triviality of figurative art to organize these according to laws that applied to art and art alone. Photography, which had been viewed with suspicion by painters, now became an abstract art form in its own right. The element of chance was treated as a creative process that freed the artist from the aliena-

Marcel Janco created masks (*above*) and engraved portraits of his friends, here Hugo Ball (*left*) and Emmy Hennings (*right*).

tion of conditioning. Dances, masks, costumes, happenings, manifestoes, declamations: art was free and would now prove it. A counterculture began to emerge in areas such as African art and children's drawings. This revolution took place without any waste of time or energy, and without the backing of any institution designed to dictate the role of culture, such as a museum or publishing house: the Cabaret Voltaire and Julius Heuberger's printing house were enough to enable a few young, free artists to change the course of art and the century.

## A Word with Various Histories

When did the name Dada first appear? In the editorial of the only issue of the *Cabaret Voltaire* review, created by Hugo Ball. How was it found? There are contradictory versions of the story, which at first was told humorously and then more seriously when, very early on, it came time to tell the story of the movement.

According to the poet Huelsenbeck, he and Hugo Ball discovered the word by chance in a Larousse German-French dictionary, while they were looking for a stage name for a singer in the cabaret. On April 18, 1916, Hugo Ball wrote: "Tzara is badgering us about publishing a periodical. My suggestion that we call it *Dada* has been accepted." Marcel

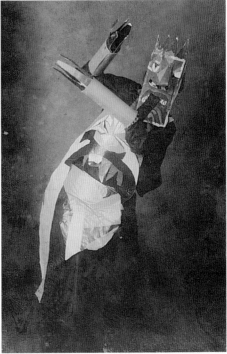

**Above:** Dancing at the Cabaret Voltaire, Sophie Taeuber in 1917, perhaps here dancing to the poem "Seahorses and Flying Fish," an onomatopoetic lament. Hugo Ball described "a dance full of splinters and bones, full of sparkling light, of penetrating intensity. The lines of her body were broken, every gesture decomposed into a hundred precise, angular, incisive movements."

# dada n. m. Cheval, d

## *Fig. et fam.* Idée fixe : c'
favorite.

Janco claimed that Tristan Tzara had found the name in the dictionary, and that the group had immediately accepted it unanimously. "It was accepted," he explained, "because it represented that feeling of naïveté, that sense of purity, of natural art, intuitive art."

This version was corroborated by a line by Tzara in the poem "Maison Flake" (Flake house), from his collection *Cinéma calendrier du coeur abstrait/maisons* (Cinema calendar of the abstract heart/houses) (1920), written at a time when the issue was not in dispute: "distended arc of my heart typewriter for the stars/who told you = broken foam of prodigious clock-sadnesses/offers you a word that cannot be found in Larousse/and wants to be your equal." Tzara himself refused to claim paternity of the name, but in January 1921 he gave a sibylline clue: "There is nothing odd about the fact that I chose DADA as the title of my magazine in 1916; I was with some friends, and I was looking in a dictionary for a word that fitted in with the sonorities of every language; it was almost dark when a green hand planted its ugliness on that page of Larousse—pointing with precision at Dada—my

**Above:** With the Cabaret Voltaire, Hugo Ball founded the home of the movement. He moved away from Dada once the formula had been invented.
**Left:** Cover of the first issue of the review, July 1917. Many were struck by the singular genius of this thinker and man of the theater, and recognized him as one of the great German writers. Arp recalled Ball at the piano, "as pale as a chalk mannequin," accompanying Huelsenbeck and his bass drum.

D A D A 1
RECUEIL LITTÉRAIRE ET ARTISTIQUE
JUILLET 1917

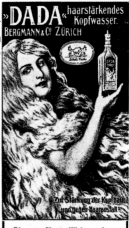

# le langage des enf
## son dada, c'est son

choice was made, I lit a cigarette and drank a black coffee. Because DADA was not meant to say anything or give any explanation for this growth of relativism that is neither a dogma nor a school, but a constellation of free individuals and facets." As for the "ugliness of a green hand," the allusion was never explained, and no doubt it never will be.

## The New Transmutation

In his *Chronique zurichoise* (Zurich chronicle), published in 1920 by the *Almanach Dada* in Berlin, Tzara added: "A word was born, no one knows how, DADA DADA we swore friendship on the new transmutation, which means nothing and was the most tremendous protestation, the most intense affirmation salvation army freedom oath mass combat speed prayer tranquility guerilla private negation and chocolate of the desperate." Even more amusing was the existence of a lotion called "Dada" that had been produced in Zurich since 1906; it was for washing hair. On July 14, 1916, Ball declared: "Dada comes from the dictionary. It's really quite simple. In French it means a small wooden horse. In German: farewell, goodbye, be seeing you. In Romanian: yes, really, you're right, that's it, fine, yes yes, we're taking care of it." After the Second World War, Tzara went further: "In the end the name chosen for the magazine was *Dada*. Our aversion to any kind of dogmatism meant that the magazine could not be open to any symbolic interpretation, which would have dragged us toward some kind of systematization of our thoughts. Legend has it that the name Dada was found when we opened the Larousse dictionary at random, and the first word we happened to see was Dada. I have often been asked

Whether "dada" was picked at random from a Larousse dictionary *(top)* or taken from an advertisement for a hair product *(above right)*, "the real Dadaists are those of the street of mirrors," as Arp explained in *The Swallow's Testicle*. "Beware of imitations/ ask in bookstores only for the Dadaists of the street of mirrors or at least for works that have not been soaked in aquadadatinta by the Dadaist Rasputin and spiritus rector tzar Tristan." The poet Clément Pansaers would point out later that in 1920 there was also a well-known brand of soap in Brussels called Dada.

if this was in fact the historical truth. But the legend is now so firmly established, accepted, and vouched for that history itself could not shake it, and in any case the boundaries between history and legend are so ill-defined that it would be presumptuous of me to intervene in one way or another. I do not mean to say, however, that the Dada legend does not correspond to the historical reality."

The confusion was complete when Jean Arp made a statement openly mocking the disputes of 1921: "Tzara found the word Dada on February 8, 1916, at six o'clock in the evening; I was present with my twelve children when for the first time Tzara pronounced this name, which quite rightly sent us into a state of rapture. That happened at the Café Terrasse in Zurich, and I was carrying a brioche in my left nostril. I am convinced that this word is of no importance, and that the only people who care about dates are imbeciles and Spanish teachers."

### "Be Sensible and Avoid Any Emotion"

Who were the Dadaists? They were artists in Zurich who responded to the announcement made by Hugo Ball in the press: Arp and Sophie Taeuber; Tristan Tzara, a young poet from Bucharest (the "Paris of the Balkans") and his friend the painter Marcel Janco, also Romanian; a young German poet and medical student, Richard Huelsenbeck, and Dr. Walter Serner, a skin specialist; Hans Richter; Otto Flake; and others.

They were all there, either because the war had prevented them from leaving or because they had come there to flee it. As an Alsatian, Jean Arp felt at home in the half-French, half-German culture of

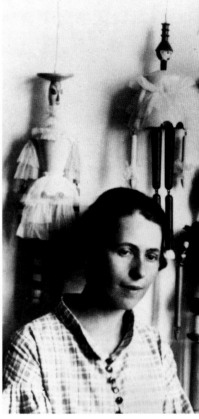

Opposite page, top right: A medical student and poet, Huelsenbeck was the "Dada drummer." He came to Zurich because he was a friend of Ball's, and stayed there for a year before returning in January 1917 to Berlin, where he formed Club Dada in March 1918. His relationship with Tzara was tinged with rivalry.

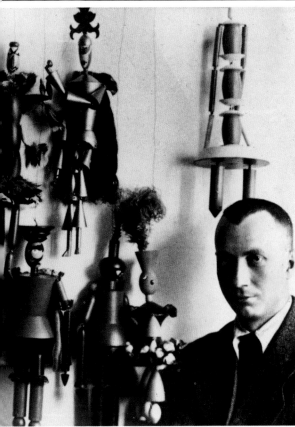

**Left:** As a couple, Jean Arp and Sophie Taeuber played an emblematic role at the heart of Dada, both for artistic reasons and because their partnership gave full recognition to the female artist. They both loved pure art, and championed both applied and fine art forms of every kind. A teacher at the School of Arts and Crafts in Zurich, Sophie Taeuber is seen here posing in front of her puppets designed for Carlo Gozzi's *Roi Hirsch* (*The Stag King*), 1918. On the right is her future husband Hans/Jean Arp, with his hair cut in an Egyptian triangle, as Tristan Tzara often described it. Sophie Taeuber was an exceptional figure who after her premature death in 1943 went down in legend as a major artist and an outstanding militant in the Constructivist tendency. "Sophie dreamed Sophie painted Sophie danced," wrote Arp. "You danced the dawn that overflows the earth./You painted the star source."

neutral Switzerland. To escape army service, he faked mental illness to the German consular authorities in Zurich. When asked to write down his age, he added up "September 16, 1887" ten times or so, and then put down the huge total he came up with. "I like working things out slowly—but wrongly," Arp wrote many years later. "I like wrong calculations—because they always give the truest results."

When Huelsenbeck was summoned, he went to the doctor for a medical certificate. "Are you one of those people known as Dadaists?" asked the doctor. "Yes, sir," answered Huelsenbeck, stiffly clicking

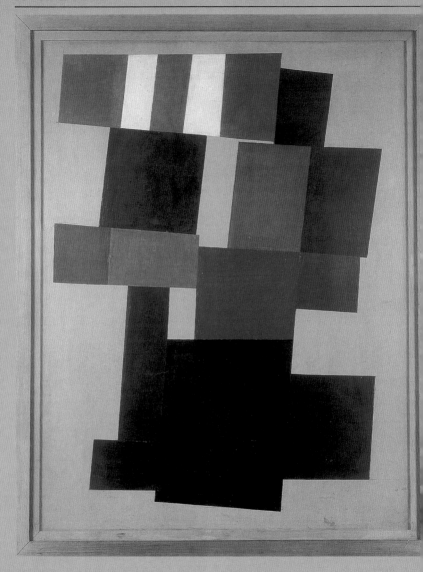

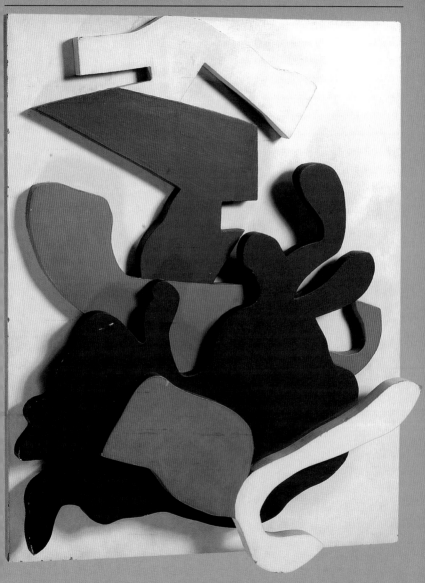

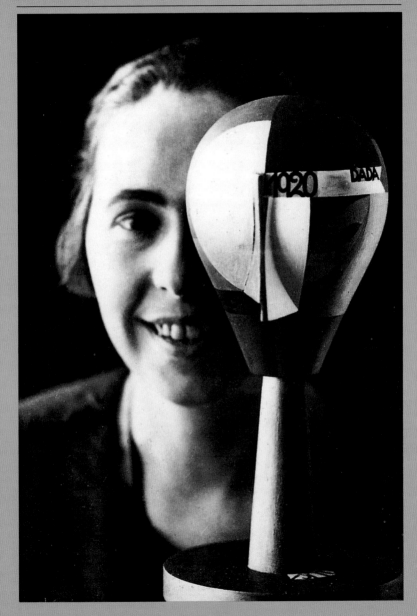

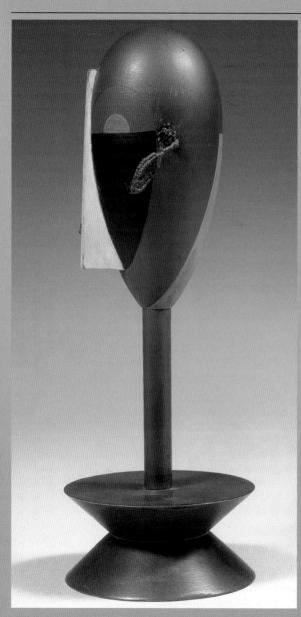

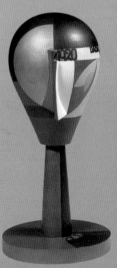

**Preceding pages:**
Never imprisoned by
a formula, the genius
of Jean Arp oscillated
freely between the
"rigorous and imper-
sonal construction
made of surfaces and
colors" of *Static
Composition* (1915,
p. 20), and the vegetal
exuberance of the
polychrome wood
relief *Flower Hammer,
Terrestrial Forms*
(1916, p. 21; published
in *391*, no. 8, February
1919). Sophie Taeuber's
art evolved somewhere
between these two
poles of the abstract
and the concrete.
She created her *Dada
Heads* (left and below),
one of which (*Portrait
de Arp*) combined
the symmetry of both
artists' embroidery
with the inventiveness
of a pure, personal,
sculptural art.

his heels as he stood under a portrait of the mustachioed Hindenburg. "Well," said the doctor in a paternal and almost melancholy voice, "we will be in touch. Be sensible and avoid any emotion or agitation."

Other artists close to the group were the painters Arthur Segal, Otto van Rees, and Adya van Rees-Dutilh. On the day the Cabaret opened, the room was packed. There were works by Janco on the walls, while Tzara read poetry, looking amused as he fished pieces of paper out of his pockets at random.

### Tristan Tzara: The Drawers of the Brain and of Social Organization

Tzara was nineteen years old when he arrived in Zurich. He took over from *Cabaret Voltaire* to launch the *Dada* review. This dazzling writer had a score to settle with the world as he found it, and he worked with an astounding energy that impressed his friends and ensured his status as a legendary figure of the twentieth century. The magazine was sent all over the world. With no backing at all, he organized publications, loans of works, exhibits. He wrote, gave lectures, and catalyzed the energy of others. He was a resounding confirmation of the independence Hugo Ball had written about in the editorial of *Cabaret Voltaire*: "When I founded the Cabaret Voltaire, I was convinced that there would be other young men in Switzerland who, like me, wanted not only to enjoy their independence, but to prove it as well.... With the help of our friends from France, Italy, and Russia, we are publishing this little journal. It will

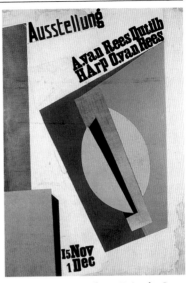

**Above:** Poster by Otto van Rees, November 1915. "The exhibit at the Tanner Gallery in Zurich was to be the most important event of my life. It was there that I met... Sophie Taeuber. This exhibit...was composed mainly of tapestries, embroideries, and collages.... I took a stand against illusion, fame, artifice, copying or plagiarism, spectacle, tight-rope walking,...and in favor of reality, the precision of the indefinable, rigorous precision...; artists were disgusted with oil painting and were looking for new materials."
—Arp, "Jalons," 1955

**Left:** Arp in 1915.

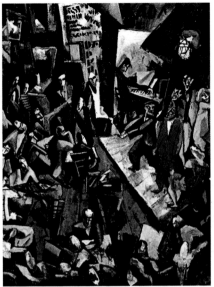

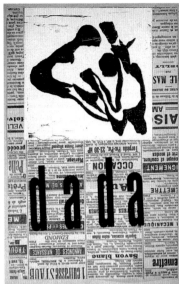

give details of the activities of this Cabaret, whose aim is to remind the world that beyond the realm of war and the homeland there are independent men who live by other ideals. The intention of the artists gathered here is to publish an international review. The review will be published in Zurich, and will bear the name DADA, Dada Dada Dada Dada."

And so the modest review *Dada*, "a literary and artistic anthology," was published in July, then December, of 1917, with works by Arp, Janco, Lüthy, and Van Rees. Typographical plates were lent to the magazine of works by Sonia Delaunay and Vasily Kandinsky, and of a canvas Giorgio de Chirico sent by Paul Guillaume, who also put Tzara in contact with Apollinaire. In addition, the review published poems by Tzara. His "Note 18 sur l'art" reads like a manifesto: "Art is at present the only thing constructed and accomplished in itself about which there is nothing more to say, so much richness, vitality, meaning, wisdom: to understand, to see."

The first title in the Dada collection was *La Première aventure céleste de Mr Antipyrine* (The

**Left:** Uproar in the *Cabaret Voltaire*, a lost canvas by Marcel Janco, 1916: Hugo Ball is at the piano, while Tristan Tzara wearing his monocle is wriggling about with his hands stretched out in front of him… Ball wrote: "I feel particularly close to Janco. He is a tall, slim man who stands out because of his confusion at the stupidity or oddness of other people, for whom he pleads for indulgence or understanding with a smile or an affectionate gesture. He is the only one of us who does not need irony to come to terms with the age we live in." **Above:** The cover of the original copies of *Dada 4–5*, engraving by Arp stuck onto a page of a newspaper, May 1916.

first celestial adventure of Mr. Antipyrine), with text by Tzara and a woodcut by Janco (July 1916). Apollinaire wrote to him: "I have admired your talent for a long time, and I admire it all the more because you have done me the honor of directing it on a path on which I precede you but do not surpass you."

Seeing the bold ideas of his artist friends, in particular Arp's collages made from papers stuck together at random, Tzara decided to try a new technique that involved not writing words, but choosing them. He would take a newspaper and scissors, cut up the words, put them in a bag, gently shake it, take the words out one by one, and write them down. He did not use this technique often, but it was a symbolic step in defiance of the organization of language. In his "1918 Dada Manifesto," Tzara proclaimed: "I am destroying the drawers of the brain and of social organization; the aim is to demoralize the whole world, to throw the hand of heaven into hell and the eyes of hell to heaven, to re-establish the fertile wheel of a universal circus in the real powers and the imagination of every individual."

## Abstract Poems

Dada was a movement of poets and painters. They worked closely together in Zurich, then Berlin, but less so in Paris, where the arrival of Dada was more of a literary phenomenon. At the Cabaret Voltaire, Hugo Ball created sound poems (*Klanggedichte*) intended to reject a language that "journalism has ravaged and made impossible," and to return to "the most intimate alchemy

KARA
jolifanto bamb
grossiga m'p
égiga gora
higo bloiko ru
hollaka holla
o bun
oung
ung
fata
a wull
ta gôr
éscnige zunb
wulubu ssubud
tumba ba- u
kusagauma
ba - umf

**ANE**

**falli bambla**

*bla horem*

**huju**

**sa ólobo**

**o ssubudu**

of the word, and even to go beyond it in order to preserve for poetry its most sacred domain." Wearing a costume (with a blue-and-white striped cylindrical shaman's hat) which he described as "cubist," he declaimed his abstract poems, including the famous "Karawane." In his *Verse ohne Worte* (Verses without words) or *Lautgedichte* (Sound poems) the vowels oscillated and were distributed solely in accordance with the opening sequence:

*gadji beri bimba/*
*glandridi lauli lonni cadori/*
*/gadjama bim beri*
*glassala/glandridi*
*glassala tuffm i zimbrabim*
*/blassa galassasa tuffm i zimbrabim…*

"With the heavy series of vowels and a rhythm that was dragging elephants," wrote Ball, "I was able to create a final crescendo. But how could I bring it to an end? It was then that I realized that my voice, in the absence of other possibilities, was adopting the ancestral cadence of sacerdotal lamentations, that style in which canticles are performed in the Eastern and Western Catholic churches." Hans Richter described Ball as being "as still as Savonarola, fantastic and pure," in the middle of a hurricane—the room was jam-packed—as still as a tower (he could not move in his cardboard costume) before an audience of "pretty girls and serious petits bourgeois who were bursting out laughing and applauding as they laughed."

Sophie Taeuber danced a letter poem with costumes and masks, some

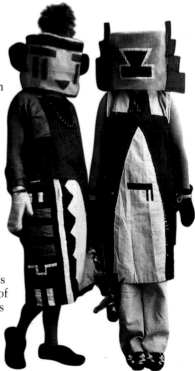

Opposite page: Ball in costume, June 23, 1916, to recite his poem; **Center:** Here in the typography of the *Almanach Dada* (1920). It is not known if Ball had heard from Kandinsky about the verbal innovations of the Russian Futurists. At the Cabaret, he acted a "Nativity with Sound Effects" and read his novel *Tenderenda the fantast* to "destroy his inner carapace." **Below:** Sophie Taeuber in Hopi costume.

designed by Janco and some by herself, and inspired by the tunics of the Hopi Kachina Indians.

Tzara had a passion for texts from Africa, Madagascar, and Oceania, and declaimed African verses from the Aranda, Kinga, Loritja, and Ba Konga tribes. In April 1917, during an exhibit of works lent by the Der Sturm gallery in Berlin, African music and dance were performed in masks by Janco that were "terrifying and usually painted a blood-red color," in the words of Arp, who went on to address this comment to Janco: "With some cardboard, paper, horsehair, and wire, you made your languorous fetuses, your lesbian sardines, your mice in ecstasy."

According to Hans Richter, "Janco's African masks transported the audience from the virgin language of the new poetry to the virgin forest of artistic visions." They had an almost disquieting effect on Ball, who explained that the masks forced those who wore them to start dancing, imposing on them "precise, pathetic gestures that border on madness," and exerting a power that communicated itself very forcefully to the group.

As a painter and architect, Janco created painted reliefs on plaster, some of which were designed to form part of a wall. In 1916 he painted a canvas entitled *Cabaret Voltaire*, which as a piece of documentary evidence is as valuable as a photograph. His engravings included the dancing characters on the cover of *La Première aventure céleste de Mr Antipyrine* (July 1916), the colored (blue and black) woodcuts inside the book, and the movement's first letterhead design.

### The "1918 Dada Manifesto"

Tzara's "1918 Dada Manifesto," which was read out on the evening of July 23, was the true founding act of the movement, without which Dada might have gone unnoticed. The text was impetuous, thundering, lucid, and demanding. Not only did the manifesto create an

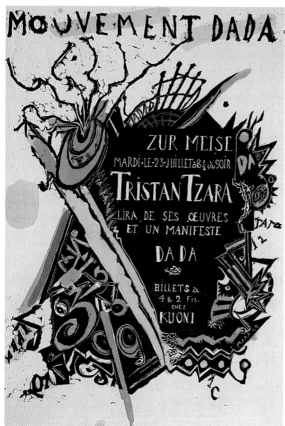

Tzara and Janco had known each other since high school in Romania, and met again in Zurich; Janco was an architecture student at a technical school, and Tzara was studying philosophy. **Opposite page:** Janco colored his woodcuts by stenciling them with gouache for *La Première aventure céleste de Mr Antipyrine* (The first celestial adventure of Mr. Antipyrine), the first anthology and masterpiece of the "Collection Dada" (July 28, 1916). **Left:** He also did the engraving for the poster for the reading of the historic "1918 Dada Manifesto," modestly advertised just as a manifesto, in the Zur Meise room.

The manifesto questioned the intelligence of the age and the meaning of art, swept away sentimental psychological waffle and morality, denounced all systems and the impotence of the spirit, proclaimed that it was possible to "bring together opposing actions," sang the praises of both permanent contradiction and affirmation, declared a "hatred" of common sense and the petty dramas of bourgeois life, and announced the total freedom of art, along with joy, spontaneity, the independence of every individual, "Dadaist disgust," and mistrust of the community. "All individualities must be respected in their madness of the moment."

immediate stir across the world, but also, following its publication Picabia came to Switzerland to meet Tzara, and André Breton invited him to Paris. "We need works that are strong, honest, precise, and forever uncompromised." For Tzara, abstraction was a struggle and a protest that was not limited to painting and other abstract works of art, nor indeed just to the field of aesthetics, which he stigmatized as "formal experimentation." He radically rejected logic: "The new painter creates a world whose elements are also the means of creation, a sober and defined world, without argument. The new artist

protests; he no longer paints [illusionistically], but creates directly in stone, wood, iron, pewter, rocks, organisms in motion that can be turned in every direction by the limpid wind of momentary sensation."

## Arp and the Laws of Chance

Legend has it that Dada was generated spontaneously, but Arp's biography, for example, shows that although Dada was a crucial moment for him, he had already exhibited with the Blaue Reiter group in Munich in 1912. Arp knew Kandinsky, Marc, Macke, Klee, and also the people at *Sturm* magazine in Berlin, including its organizer, Herwarth Walden. He had been friendly with Max Ernst in Cologne, and had lived in Montmartre, having traveled there on the last train before the general mobilization of August 1, 1914. He is linked with the artist Sophie Taeuber, a teacher at the School of Arts and Crafts in Zurich, whom he met in 1915 and married in 1922.

Arp created biomorphic works (*The Tears of Enoch, The Burial of the Birds and Butterflies* or *Portrait of Tristan Tzara*), rigorous paper collages, and also torn-up pieces of paper arranged "according to the laws of chance." His sensibility was wide-ranging enough to include a Constructivist element. Reliefs made from pieces of wood painted and screwed together, automatic drawings in india ink on paper, wood engravings for Tzara's collections (*Vingt-cinq poèmes* and *Cinéma calendrier du coeur abstrait/maisons*), torn-up pieces of paper, embroideries. Arp's genius dazzled his friends. He "moved away from the aesthetic" in search of a new relationship between man

As an all-round perfectionistic artist—he destroyed many of his works (to explain "the pleasure of destroying," he would say later, "would take me too far")—and accomplished poet, Arp was one of the first to lose interest in virtuosity and invent creative processes that would liberate art: the rejection of oil painting, the use of cut-up paper, etc. The technique of chance, suggested to him by something that happened accidentally, enabled him to break away from standard aesthetics. **Below:** Chance (sometimes a "dream," Arp was to say) played a crucial role at the Dada soirées, offering a new freedom in both their organization and their listing in the *Chronique zurichoise*.

In the 1960s, the American composer John Cage would experiment with "chance operations" as a means of escaping from the "intentional."

1919 — 9 Avril

Non PLUS ultra

Salle Kaufleuten

NON PLUS ULTRA

9. DadA-SOIRÉE

Metteur en scène: W. SERNER

Dompteur des acrobates: TZARA

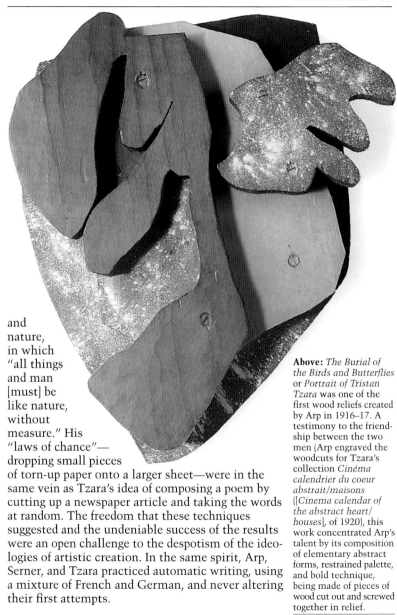

and
nature,
in which
"all things
and man
[must] be
like nature,
without
measure." His
"laws of chance"—
dropping small pieces
of torn-up paper onto a larger sheet—were in the
same vein as Tzara's idea of composing a poem by
cutting up a newspaper article and taking the words
at random. The freedom that these techniques
suggested and the undeniable success of the results
were an open challenge to the despotism of the ideo-
logies of artistic creation. In the same spirit, Arp,
Serner, and Tzara practiced automatic writing, using
a mixture of French and German, and never altering
their first attempts.

**Above:** *The Burial of the Birds and Butterflies* or *Portrait of Tristan Tzara* was one of the first wood reliefs created by Arp in 1916–17. A testimony to the friend-ship between the two men (Arp engraved the woodcuts for Tzara's collection *Cinéma calendrier du coeur abstrait/maisons* ([*Cinema calendar of the abstract heart/houses*], of 1920), this work concentrated Arp's talent by its composition of elementary abstract forms, restrained palette, and bold technique, being made of pieces of wood cut out and screwed together in relief.

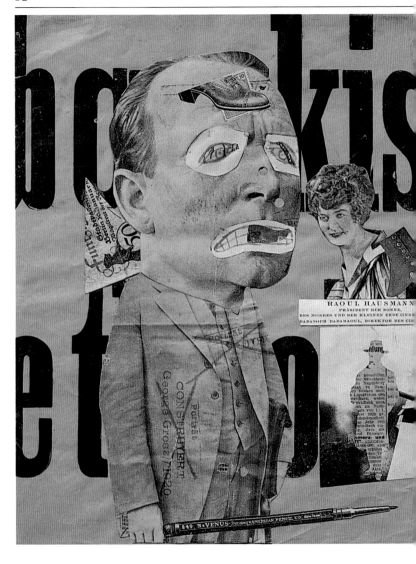

An injection of the "virgin microbe" Dada into a society in mid-collapse produced a double explosion in Berlin, affecting not just the world of art but of politics as well. The radical socialist Spartacists confronted the army in the streets of a city that was starving and in ruins, while the Dadaists showed what the revolution ought to be: a transformation of aesthetic and mental attitudes that would prevent a society in upheaval from losing its way in the delusions of politics and returning to bourgeois narrow-mindedness.

CHAPTER 2

# BERLIN: THE REVOLUTIONARY IMPULSE

**Left:** Mechanical Head by Dadasopher Raoul Hausmann: *The Spirit of Our Time* (1920).
**Opposite page:** Hausmann's photomontage *The Art Critic* (1920) breaks up the laws of association and juxtaposes images, information, and emotion in an intensely critical caricature.

As Tzara explained in the "1918 Dada Manifesto," Dada was born of a feeling of mistrust of the "community." In the evening of his life, living in Paris in 1963 and no doubt weary of seeing the deeper meaning of this rejection of society apparently forever destined to be caricatured and reduced to a few spectacular or absurd events, he gave an interview shortly before his death. Then he declared: "Dada had a human purpose, an extremely strong ethical purpose! The writer made no concessions to the situation, to opinion, to money. We were given a rough ride by the press and by society, which proved that we had not made any compromise with them. Essentially we were very revolutionary and very intransigent; Dada was not just absurd, not just a joke, Dada was an expression of a very great adolescent pain that came into being during the First World War and the time of suffering. What we wanted was to make a clean sweep of existing values, but also, in fact, to replace them with the highest of human values."

Even more than in Zurich, this "pain" and this "clean sweep" ruled the daily lives of the Dada group that formed in Berlin after the return of Huelsenbeck, then a medical student. The intensity of the situation was reflected in the range of sympathies that ran through the Dada constellation; some were individualist anarchists, such as Raoul Hausmann the "Dadasopher," Hannah Höch, and Superdada Johannes Baader, while others more anchored in the political struggle of the left were Wieland Herzfelde, the founder of Malik Verlag, his brother John Heartfield, known as the Dadamonteur or "Fitter Dada," and the Marshall of Dada Propaganda, painter and draftsman George Grosz. Defeated and destroyed, Germany was in a state of revolution: general strikes, military repression, the struggle for power between the Social Democrats and the Spartacists following the abdication of the emperor

**Above:** Raoul Hausmann's *Self-portrait of the Dadasopher*, collage-photomontage, 1920.
**Above right:** "Brothers! Do not shoot!" The German people ask the soldiers not to shoot at their working-class brothers in revolt.
**Below right:** *Futur* (1920), a collage by Baader, the supreme Dada and founder of the Blue Milky Way Club.

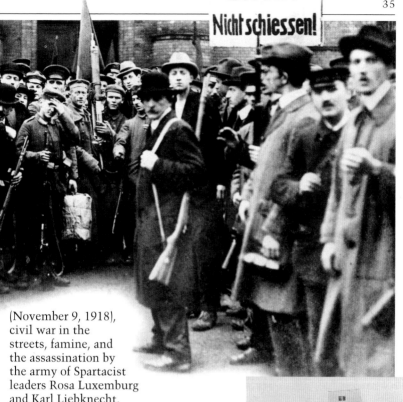

(November 9, 1918),
civil war in the
streets, famine, and
the assassination by
the army of Spartacist
leaders Rosa Luxemburg
and Karl Liebknecht.

## "The Hubbub of Life's Cataracts"

An initial grand Dada soirée took place in
April 1918 in the Secession Hall in Berlin.
Huelsenbeck published the first Berlin
"Dada Manifesto": "The greatest art will
be that which consciously represents in its
content the many problems of the age,
that which gives the feeling that, shaken
by the explosions of the previous week, it
is picking up its limbs from under the
blows of the day before. The best artists,
the most extraordinary, will be those who,
at all times, carry on with the remnants of
their bodies amid the hubbub of the

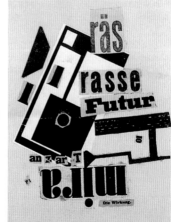

cataracts of life, and, relentlessly hounding the intellect of the time, bleed from their hands and hearts…. For Dadaism in words and images, for Dadaist events in the world. To be against this manifesto is to be Dadaist!" There followed the formation of Club Dada; the publication of the review *Der Dada* in collaboration with the anarchist writer Franz Jung, who was already editor of the *Freie Strasse*; and an intense period of pictorial, theoretical, and political activity (in the last case, criticism of any kind of proletarian conformism).

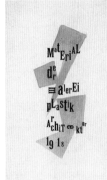

**Above:** Raoul Hausmann, *Material for Painting, Sculpture, Architecture*, 1918, a stencil using color, inversion, and a mixture of characters to form an optical poem of words and letters.
**Below:** *Der Dada 3.*

## Photomontage: A Fresh Kind of Content

Raoul Hausmann proclaimed the arrival of a new material in pictorial art. He invented the photomontage, which he could see had great propaganda potential in a contemporary world that in his opinion was not sufficiently daring. He formed a passion for "the new material's ability to irritate, and in so doing lead to more fresh types of content." In *Courier Dada* he commented: "A very large number of the first photomontages followed contemporary events with biting irony. But the idea of the photomontage was as revolutionary as its content, its form as amazing as the use of both photography and printed texts, which together turned into a static film. Having invented the static, simultaneous, and purely phonetic poem, the Dadaists now applied the same principles to pictorial expression. They were the first to use photography as a material with which very different structures, often heterogeneous and with conflicting meanings, could be mixed to create a new entity that drew from the chaos of the war and the revolution an intentionally new optical image."

Raoul Hausmann's many talents included painting, drawing, photography, photomontage, concrete visual poetry, and sound poetry; he

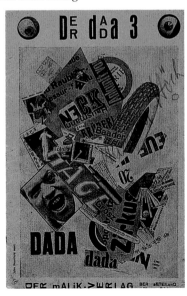

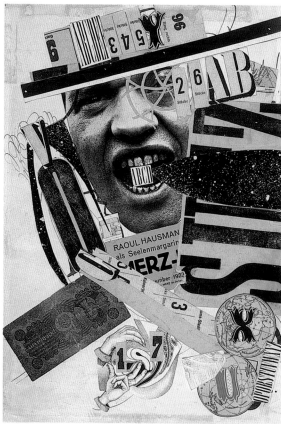

**Left:** Letters, vocalization, utterances, and typographical characters, notably those of the poster poems, were the driving force behind Raoul Hausmann's photomontages, such as *ABCD* (*near left*), composed in 1923–24. At the center of the composition are Hausmann himself and a ticket for the Merz matinee on December 30 at the Tivoli in Hanover. The photomontage is a visual manifesto, a concentration of space and time that opposes its own complexity to that of the time. No one defined the photomontage better than William Burroughs in *Nova Express* (1964): "A statement in flexible picture language— A technician learns to think and write in association blocks which can then be manipulated according to the laws of association and juxtaposition—The formulae of course control populations of the world—Yes it is fairly easy to predict what people will think see feel and hear a thousand years from now if you write the Juxtaposition Formulae to be used in that period."

was also a theorist, prose writer, scathing political polemicist, technician, journalist, historian, review editor, dancer, and performer. He made a study of sound and light phenomena, wrote a treatise on optophonetics, and in 1935 went to London with the Russian engineer Daniel Broïdo to secure an inventor's patent for the optophone. Using large wooden characters normally used for posters, Hausmann composed "poster poems" or "letter poems": "fmsbwtözäu," "fmsbw," "OFFEA," "Kp'erioum." These letters did not form normal dictionary words, but when each character was shown in this concrete

way, dissociated from its normal function, and then juxtaposed with another, it not only had a visual impact, but also produced a sound effect (which Kurt Schwitters was to seize upon). Far from Hugo Ball's abstract, monotonous chanting at the Cabaret Voltaire, Raoul Hausmann's poster poems offered the viewer not just a striking form of typography, but also sonority and rhythm. Hausmann danced to his poems. "Everything starts with dance," he said, "movements come long before verbal expression or even music, because dance has its own music. When you are standing there, you are not in space but outside space, you are not on earth or outside the earth, and it is from this point that creation begins: build for yourself the walls and limits of your universe."

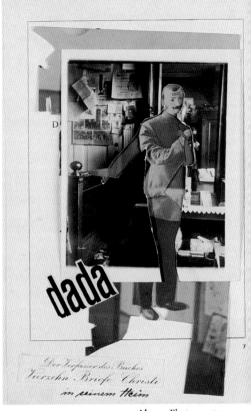

7

**Johannes Baader, the Intertelluric Dadaist**
Self-proclaimed in February 1918 as the "President of the League of Superdadaist Intertelluric Nations," Johannes Baader, known as the Oberdada or Superdada, took his place on the "saddle of the Dada white horse." In 1919 a photomontage showed him head-to-foot with Hausmann. Apart from a few moments of discord caused by the unpredictable Baader, the two men had a sparkling friendship. Hausmann had found in Baader a man capable of "knocking his head through walls for an idea." The Dadasopher and the Superdada wrote press releases at night that

**Above:** Photomontage by Baader, *The Author of the Book* Fourteen Letters of Christ *in His Home* (1918–19). The Superdada Baader challenges the world. In 1916, as a soldier, he wrote to the Crown Prince, exhorting him to stop the war. The authorities accused him of irresponsible behavior. In 1941, the gestapo ordered him to stop writing to Hitler.

appeared the next day in the newspapers: "The Dadaists demand the Nobel Peace Prize," "Minister Scheidemann takes part in Dada," "Men are angels and live in heaven."

Baader interrupted a pastor in the Berlin Cathedral by shouting, "You are making a mockery of Christ." After his arrest he continued the controversy in the press; he could not be charged with blasphemy, since he was reproaching the Church for not respecting the teachings of Christ. In the *Berliner Tagesblatt*, Baader struck out: "The assertion by the press that this is a matter of mental illness seems to me to be one of the methods that are used today when a man becomes embarrassing." Baader and Hausmann decided to found an imaginary Dada Republic at Nicolassee by putting up posters proclaiming an independent republic. On the appointed day, the Town Hall was surrounded by soldiers brought in by the authorities, who had fallen for the joke.

**Below:** One of Hausmann's poster poems (1918) printed with the large wooden characters that the Club Dada used to print the slogans hung among the pictures at the Dada Fair. It includes the vertical hand with pointed index finger that is characteristic of Dada and was Tzara's distinctive sign.
**Bottom:** Baader and Hausmann as inverted Siamese twins (1920).

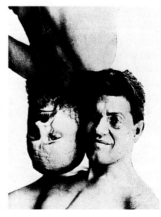

## A New Meaning

On a street right in the middle of the bourgeois neighborhood of Steglitz, the Dadaists opened a venue in a back room store, where Baader lounged naked on a luxurious red divan while in the front room Hausmann and Heartfield sold tickets. Baader arrived by helicopter in the middle of a gathering of people, all of whom claimed to be the new Christ. On a summer evening in 1918, Baader and Hausmann improvised a spontaneous "happening" to mark the one hundredth birthday of the author Gottfried Keller. In the middle of the Rheinstrasse in Friedenau, they leafed at random through Keller's *Der Grüne Heinrich* (*Green Henry*), and took turns to

pick out phrases here and there, with no beginning or end, and recite them in different voices, changing the rhythm and sense. "That gave a new meaning, and wonderful combinations....We were alone in the world, surrounded by the whole world, which had disappeared into the abyss of our poetic inspiration, absorbed as we were by our new inventions. It was the very latest thing in prefabricated poetry! The ultimate language of a mutual understanding, rising above the tarnished conventionalities—we stood there like two trunks of the same tree. The words of the book seemed mysterious to us, lit up by our exalted voices, lent wings by our spirit of rapture, tormented by new combinations, a meaning beyond meaning and comprehension."

Baader put together a now-legendary book, which was a private journal or scrapbook with press cuttings and pieces of posters torn off in the streets. He called it the *Handbook of Superdadaism*, referred to by its acronym *HADO* (*Handbuch des Oberdadaismus*), and sometimes as the *Judgment Day Book* (*Buch des Weltgerichts*). Ben Hecht, later a famous scriptwriter, came to Berlin at this time as a reporter from Chicago and frequented the Dada circle, where he was known as Ben-Dada or Ehrendada (Dada of Honor). He tried to buy the *Handbook* at the end of a Dada demonstration that consisted of a speed contest between six typewriters and six sewing machines, followed by a jousting match of insults. In his usual grandiose way, however, Baader quoted him a preposterously high price. Grosz later ventured the hypothesis that Baader had buried his masterpiece near his house in Lichterfelde-Est.

### The First International Dada Fair
The First International Dada Fair (*Dada-Messe*) in June 1920 was a major event in the art world. It showed photomontages and collages by Raoul Hausmann and Hannah Höch, as well as Grosz's

"Baader had a beard, and a very handsome face. One of the symptoms that showed that something was wrong in Germany was the number of people who claimed to be Christ. A large meeting was held to distinguish the real Christ from the impostors. Baader did an incredible thing; as a journalist, he was offered a ride in an experimental plane by Lufthansa. He got them to drop him in Thüringen, in the middle of the field. They saw him, Baader, coming down from the sky. He landed, then turned round.

They saw his face, and were filled with horror! I wondered if it was a Dada-type joke, or whether deep down he was beginning to think he really was Christ."

—Vera Broido Cohn, in *Apeiros*, 1974

**Above:** Poster catalogue of the First Dada Fair, Berlin, 1920.

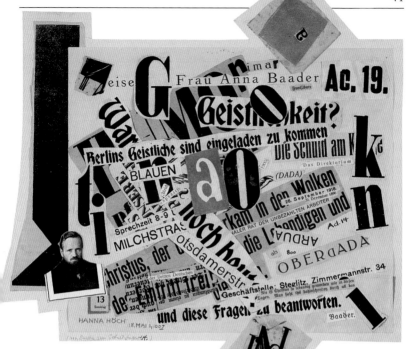

most accomplished works and a
large mixed-media construction by
Johannes Baader. The exhibit's poster
catalogue includes a simultaneous montage of
urban surroundings by John Heartfield, *Leben und
Treiben in Universal-City, 12 Uhr 5 mittags* (*Life and
Activity in Universal-City, Five in the Afternoon*), and
a quotation from Hausmann: "The individual Dadaist
is a radical opponent of exploitation; a sense of
exploitation produces nothing but stupid idiots and
the individual Dadaist hates stupidity and loves
nonsense! So the individual Dadaist shows himself
to be truly real compared to the bumptious falseness
of the paterfamilias or the bloated capitalist sitting
in his armchair." The inner pages show a "corrected
Picasso," a Rousseau presented as a "corrected
masterpiece," and works by the painters: a canvas
by George Grosz, *Deutschland, ein Wintermärchen*

**Above:** Baader's
logic was based
on autobiographical
structuring and
accumulation. In
this collage are press
cuttings about him,
allusions to the Blue
Milky Way Club
(*Blauen Milchstrasse*),
and to his appearance
as Christ in the clouds
(*in den Wolken*), a
central "a" taken
from the Dada logo
designed by Hausmann,
and his photograph.
*Potsdamerstrasse*
refers to the morning
of June 6, 1918 in the
Café Austria.

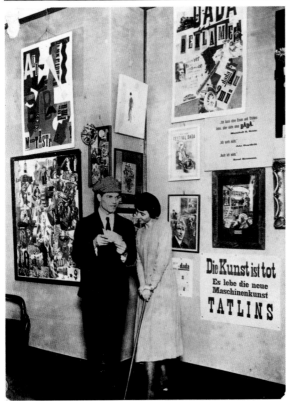

(*Germany, a Winter's Tale*, 1917), subsequently destroyed by the National Socialists; his famous montage *Remember Uncle August, the Unhappy Inventor*; and the fan he made for the cover of *Jedermann sein eigener Fussball* (*Everyone His Own Football*); a small painting by Max Ernst (*Muslins and Marseillaise of Dada Arp*, 1919); and finally Georg Scholz (*Bauernbild*) and Otto Dix, *45% Erwerbsfähig!* (*45% Capable of Work!*). The works were hung the old-fashioned way, occupying all levels of the walls and giving them a beautiful intensity. Hanging down from above was a "ceiling sculpture" *Prussian Archangel* by Heartfield and Schlichter, which was a greenish gray dummy of a

German officer with a pig's head, a military cap, and a sign around its neck that read, "Hanged by the revolution." Another notice said: "In order to understand this work of art, it is essential that every day, wearing combat dress and weighed down by a heavily loaded rucksack, you do exercises for ten hours a day on the Tempelhof training ground." There were posters with messages such as "Dada for all," "Dada is against the artistic trickery of Expressionism," "Dilettantes, rise up against art!" "Dada is the opposite of the inexperience of life," "Dada is on the side of the revolutionary proletariat," "Unlock your head at last, open it up to the demands of the time," "Down with art! Down with bourgeois spirituality," "Dada is the deliberate subversion of bourgeois values." Finally, as evidence of the changes that were underway, was a premonitory quotation from the Symbolist painter Wiertz: "One day photography will supplant and replace the whole of pictorial art."

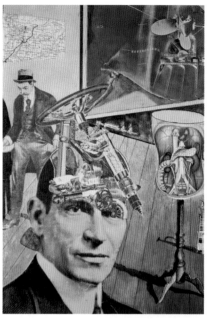

**"Art Is Dead, Long Live the New Mechanical Art"**
A canvas by Otto Dix marked the boundary between two groups of works, Raoul Hausmann's large photomontages and collages (*The Art Critic, Dada siegt, Tatlin at Home*), and the satirical-mechanical drawings (*The Iron Hindenburg, German Freedom*). Beneath *Tatlin at Home* were the words: "Art is dead/Long live the new mechanical art/of Tatlin." A photo in the *Dada Almanach* shows Grosz and Heartfield standing in front of their *Enraged Bourgeois*, an "electromechanical Tatlinian sculpture" that consisted of a dummy with its lightbulb head switched on, its right leg

amputated to the knee, a shell or set of teeth instead of a penis, and a piece of cardboard bearing the number "27" halfway between the navel and the solar plexus. On its left shoulder was a handbell on a small plank of wood, and it had a fork at the level of the heart, a pendant round its neck, and a barrel revolver in place of a right arm.

Above the dummy by Grosz and Heartfield, lit by a lightbulb, was a mechanical drawing by Max Ernst, *Erectio sine qua non*, which represented the Cologne group along with a photomontage by Johannes Baargeld based on a bust of the Venus de Milo, and described as a "characteristic vertical hotch-potch representing dada Baargeld."

In the second room Baader constructed a montage called the *Plasto-Dio-Dada-Drama* for which he himself wrote the "Instructions for Contemplation." In it he imagined a paradisiacal park project for the Zoological Gardens in Paris, for the benefit of French and German Dadaists. Later it was in fact Baader who, while working for a firm of architects, designed the first zoo without bars (at Stellingen, near Hamburg).

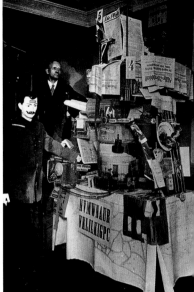

### The Dada Lawsuit, Confiscated Art

According to Hausmann, the Dada Fair was the point of departure for modern art on an international scale. "I always blamed Grosz and Heartfield for their sentimental bourgeois side," he wrote later. "Most of the visitors were intellectuals who accepted Dada's daring ideas in advance. But one day, a colonel from the Reichswehr came to see the exhibit, and was extremely indignant. I happened to be the only Dadaist present, and he said to me, 'You are all criminals and you all ought to be shot!' I answered, 'Go ahead, go ahead, we'll enjoy it!' Whereupon he left in a fury. It was the same officer who testified on April 12, 1921 in the libel action brought against Dada by the Reichswehr."

"Grandeur and Decadence of Germany by Schoolteacher Hagendorf. Fantastical history of the life of Superdada. Monumental Dadaist architecture on six floors with three units, a tunnel, two elevators, and a layered cylindrical structure. First floor: destiny predetermined before birth. Other floors:
2. The preparation of Superdada.
3. The metaphysical test.
4. The initiation.
5. The World War.
6. The World Revolution."

—Baader, description of the *Plasto-Dio-Dada-Drama* (*above*)

The authorities were highly offended by the officer with the pig's head, and also by Grosz's uncompromizing satirical album of sketches, *God with Us*, published by Malik Verlag. Grosz, Heartfield, and Schlichter were charged with an "affront to the armed forces of the Reich" and Otto Burchard, with having invited them to exhibit in his gallery. The prosecuting attorney demanded six weeks' imprisonment for Grosz and Herzfelde (Heartfield's real name). To compensate the Ministry for the Armed Forces of the Reich, the printing and photographic plates for the exhibit were confiscated or destroyed, and publication rights were withdrawn.

### From Zurich to Japan: *Almanach Dada*

In the period after the Fair, Huelsenbeck edited the *Almanach Dada*, in which Schwitters was attacked and Tzara wrote a spectacular, breathless "Zurich Chronicle" telling the story of the original group. The volume contains a theory of Dadaism by Daimonides (Dr. Carl Doehmann, the Dada pianist), and

**Below, inset:** A montage by John Heartfield for Kurt Tucholsky's book *Deutschland, Deutschland über alles* (1929). Tucholsky found the trial that followed bewilderingly evasive and non-confrontational. **Bottom:** A room at the Dada Fair, with Hannah Höch, seated and Raoul Hausmann, standing. On the ceiling, the litigious sculpture.

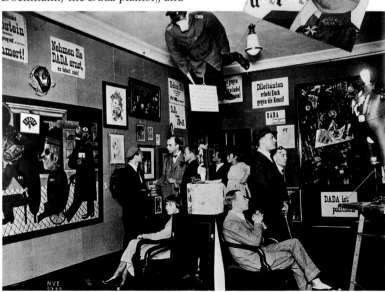

contributions by lesser-known Dadaists such as Walter Mehring, who foretold that Dada would reach Japan, as indeed it did when Murayama, having spent nine months in Berlin in 1922, founded the Mavo group and journal in Tokyo. The Chaplinesque Dutch Dadaist Paul Citroën wrote to the Berliners to persuade them not to go to Holland. In 1920 Huelsenbeck published not only a new edition of his *Fantastic Prayers* (illustrated by Grosz), but also *En avant Dada, Die Geschichte des Dadaismus* (En avant Dada, the history of Dadaism), which was the first biased, anti-Tzara historical account of the movement, described by Marcel Duchamp as "venomous"; *Dada siegt* (Dada will win); and *Deutschland muss untergehen* (Germany must perish).

## A Clone of Dada: Merz

One October evening in 1918, Kurt Schwitters came to meet Hausmann at the Café des Westens in Berlin. He wanted to join the Dada Club, but Huelsenbeck vetoed his membership; Schwitters was compromised by his association with Der Sturm (the name of Herwarth Walden's Expressionist group and periodical, which Huelsenbeck and Hausmann condemned for having published a *Song of Songs of Prussianism*), and Huelsenbeck did not like his poetry (although in Zurich Tzara was to recognize Schwitters as one of his own).

As a result, Schwitters recreated a Dada all his own. He took the syllable *merz* out of Kommerzbank, probably while composing a collage, and Merz was born. Like Dada, the word comes in a variety of forms: *Merzbau* (Merz construction), *Merzbild* (Merz image), *Merzzeichnung* (Merz drawing), *Merzbühne* (Merz theater), *Merzdichtung* (Merz poetry). Merz became the label for a process of transformation or

The slogan "The real Dadaists are against Dada" seems to have been written for Schwitters (*above*). Whether Merz was a rebellion against Dada or a graft taken from it, it turned out to be the most inventive of the Dadaist offshoots, and became a movement in its own right, a variant of Dada that was adjustable to personal need. The hijacking of one syllable from the vocabulary of world of finance (*Kommerzbank*) to be used for poetic ends was a highly symbolic initial act, and a sign of many other "Merz-words" to come.

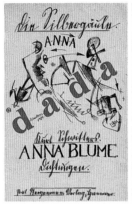  

creation ex nihilo: constructions, paintings, collages, plays, or poems. Schwitters was also a writer. In 1919, he had a resounding success with his collection of poems, *Anna Blume* (with a poem he recast in English as "Eve Blossom"), which was an ironic, sumptuous subversion of the sentimental poem.

Although Merz became his name, his work, and his life itself, Schwitters left the matter of defining it very open. The meaning of the concept gradually became clearer from 1920 on, as it evolved and knowledge and awareness of it grew. There was just one condition: "Merz aims for freedom from anything that stands in the way of *forming* artistically. Freedom does not mean unbridled license, but the product of a rigorous artistic discipline.... An artist must have the right, for instance, to make a picture by putting together pieces of blotting paper, if he knows how to form.... I am interested in other artistic disciplines such as poetry. The elements of poetic art are letters, syllables, words, phrases. From the reciprocal opening up of these elements, poetry is born. The meaning is important only to the extent that it is put to good use in the same way as each of the other factors."

From then on, Schwitters embarked on an infinitely personal path. On the basis of the concept that he had developed, he created elemental letter poems: "Cigarren" (1921), and at the end of his life, "Ribble

**Left:** Published in Hanover by Paul Steegemann in 1919 and stuck up on placards around the city, the poem "Anna Blume" made Schwitters famous in just a few days. Later, he translated it into English as "Eve Blossom." In it he sang with languorous innuendo of the "beloved of [his] twenty-seven senses... Prize question: Eve Blossom is red. 2. Eve Blossom has wheels, 3.What color are the wheels? Blue is the color of your yellow hair. Red is the whirl of your green wheels."
**Center:** Huelsenbeck's *Fantastic Prayers*, published by Malik with a drawing by Grosz. Huelsenbeck did not invite Schwitters to contribute to the *Almanach Dada* (*above, right*), with the death mask of Beethoven "improved" by the Dadaist Oz Schmalhausen.

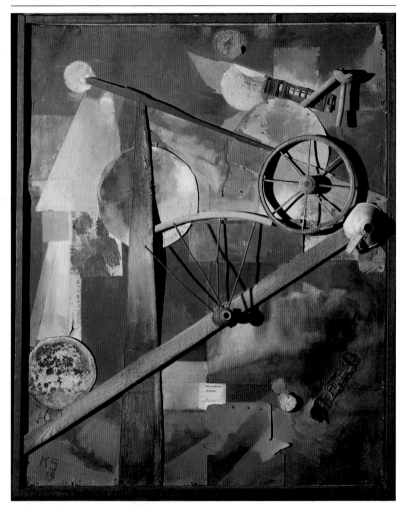

Bobble Pimlico" (1946), "Rackedika" (1946), "In grr grwrie" (1945–47).

## A Sonata of Primordial Sounds

In September 1921, after the Merz anti-Dada soirée that Schwitters gave in Prague with Hannah Höch and Raoul Hausmann, he was on the way home

*Construction for Noble Ladies*, 1919. Desolation, ruins. Schwitters loved the energy and beauty of abandoned materials, saved by his creative Merz logic.

when one morning in Lovosice he grabbed hold of Hausmann's *f m s b w t ö z ä u, p g i f f, p g i f f, mü*, and "couldn't put it down all day." "When he got home," wrote Hausmann in 1958, "Schwitters started again with *f m s, f m s*, over and over again, it was a bit too much in the end. That was how his *Sonata in Primitive Sounds* started."

At first Schwitters recited the poem with the title "Portrait of Raoul Hausmann," but afterward he made it longer ("he enlarged it by repeating it fifty times"), added a *lanke trr gll* scherzo and other sections such as the "melodies" based on the words *Dresden* and *Rackete* (rocket). In 1932 the *Sonata in Primitive Sounds* came out as a record with the twenty-fourth issue of his *Merz* periodical, with the score typographically set down by the famous Jan Tschichold.

## Merz Collages

While the Cubists were integrating diverse fragments in their works, Schwitters went much further ahead. In a Germany in ruins, he directly salvaged all kinds of scrap material. It was an activity charged with meaning: "Since the country was ruined," he wrote, "I economized by using whatever came to hand. One can cry out with pieces of garbage too, and that is what I did, by gluing and nailing them together." Above all, Schwitters was an assembler-creator who insisted in his writings on recognition, "opening out," making the best use of materials, and the relations that develop between them.

Schwitters excelled in collages of cut-up paper, of which he became the undisputed master, leaving Picasso and Ernst far behind. His work was characterized by rhythm, accumulation, and superimposition, and by the use of tearing, scrap material, pieces of printed text (the Merz cutting process), and Gothic, or modern print (an explosion of vocal and visual discourse).

**Below:** The visual and sonorous aspects of typographical characters played a key role in the revolution of words. Hausmann created the poster poem (1918), and Schwitters wrote letter poems. Language has hidden poetic qualities, opens up an untapped field of meanings, escapes from the order of culture by revealing its literal qualities.

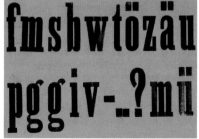

## *Merzbau*

Not only did Schwitters bring the humblest of materials into the field of art, charged with their history and nostalgia; he also developed an absolutely new type of work, which went beyond all imaginable dimensions, and could not be shown in a museum (*Merzbau* was "readymade" in reverse: here, art itself was refuting the value of the museum). With *Merzbau* (Merz construction), Schwitters reappropriated space and designed it with an extreme three-dimensional and rhythmic beauty in his home in Hanover. The first Hanover *Merzbau* (1923–36) was destroyed in 1943 by the Allied bombardments. Nothing of it survives but period photographs, which enhance its mythical status. Out of fear of being arrested he fled to Lysaker, near Oslo; in 1937 he undertook another *Merzbau*, which was destroyed by fire in 1951. He then went to England to escape from German troops, and after seventeen months of internment as a German citizen, he settled in Ambleside and started a third one in 1947, which he called *Merzbarn*.

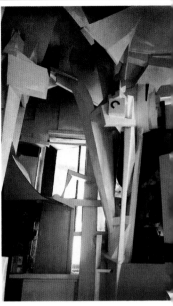

The legendary *Merzbau*. An attempt was made in 1988 to recreate a smaller version of the *Merzbau* based on photographs from 1933 (*above and right*). Schwitters built it in his family home, asking lodgers to leave when he wanted to pierce through to the upper floor. Endlessly altered, recovered, and enlarged, the *Merzbau* was an autobiographical work, an intimate sculptural journal, a prototype for physical space, a logistics of Schwitters's imagination. Under threat in Nazi Germany, he left in 1937 and never saw the *Merzbau* again.

The first *Merzbau* (about 11 x 6 x 3 feet) was in the form of a column that passed through two floors of the building, after the house had been "pierced from top to bottom by passages like mineshafts, by artificially created crevices passing through the floors of the house, by spiral-shaped tunnels linking the cellar with the roof," as Arp described.

Also known as the "cathedral of erotic misery," the *Merzbau* was woven with autobiographical elements "in pure form." There were cavities and grottoes lit by lightbulbs; the "sadistic grotto" revealed the mutilated body of a "sorely missed" young girl surrounded by offerings. A 10-percent-disabled war invalid stood next to his headless daughter, who was called Mona Hausmann. She was in fact a reproduction of the *Mona Lisa* and, as Schwitters explained, the fact that her face had

been replaced by that of Hausmann took away her "stereotypical smile." Other grottoes showed the treasure of the Nibelungen, a Goethe grotto with one of Goethe's legs as a relic, and some "pencils used almost to the end by poetry," a corner dedicated to Luther, and a brothel with a three-legged woman designed by Hannah Höch.

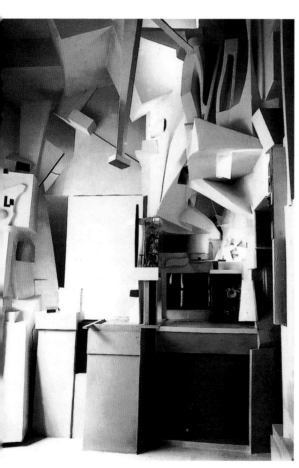

Schwitters regarded his Merz construction as being incomplete on principle, and compared the global impression it made to Cubist painting, Gothic architecture, or an urban building site on which various architectures are superimposed. He inserted odd objects into it "while respecting the rhythm of the whole." Valleys, hollows, and grottoes had their own life within it. From his sardonic observations, which were worthy of his poetic work, it is clear that he experienced the *Merzbau* as a complete artistic and literary event.

Started after the meeting between Dada and the Constructivists in Weimar (1922), the *Merzbau* can also be interpreted as a Utopian response ("an art more art," said Tzara) to the functional imperatives of the Bauhaus (industrial design). It was contemporary with the founding of the *Merz* review, the creation of the *Sonata in Primitive Sounds*, and the friendship with Theo van Doesburg that in 1923 led to a memorable "Merz" tour in Holland. Wearing a dinner jacket and monocle, van Doesburg proclaimed, "Life is an extraordinary invention," while Schwitters, hidden in the audience, barked.

Schwitters fled Germany in 1937, never to return (his friends were arrested by the gestapo, and his works were shown and defamed by the Nazis in exhibitions of Entartete Kunst [degenerate art]). He took refuge in Norway, then in England (1940), where he died in 1948 after a bleak period in exile that he faced up to with extraordinary elegance and creative perseverance. Determined, imperturbable, and witty, Schwitters was the complete artist; in addition to the *Merzbau*, he invented sound and visual poetry, and left behind typographical works, poems, stories, manifestoes, and theoretical texts. Despite his difficulties as an artist in exile with no income, he practiced collage at all times, and his manifest superiority as an artist who knew how to "form" has now been recognized for some fifteen years. **Opposite page, top:** *Merzzeichnung 219,* 1921. **Bottom:** *Zeichnung A2: Hansi,* 1918. **Near left:** *Merz elikan,* ca. 1925.

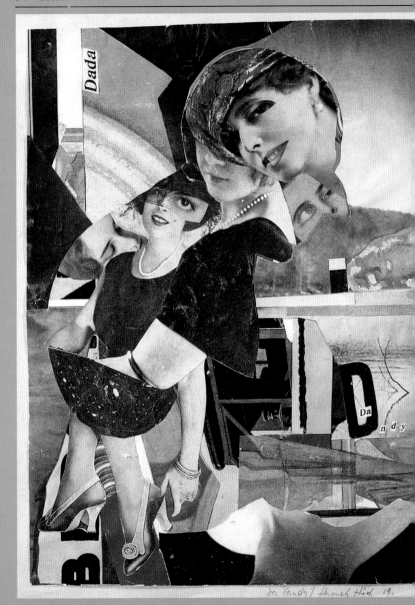

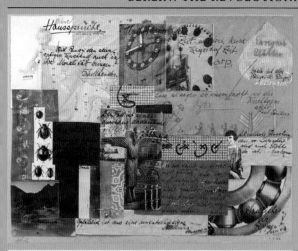

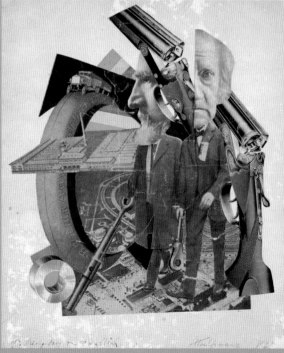

Hannah Höch developed an aesthetic that was very much her own in the field of photomontage. **Bottom:** Dedicated to Moholy-Nagy, *High Finance* (1923) mixes tools, guns, factories, and tires, and splits a front view of a face to replace half of it by a profile. **Opposite page:** In contrast, *Da Dandy* (1919) could not be more "feminine." Faces, legs, and women's shoes are cut up and arranged with the same sureness of touch that characterized Hannah Höch's sense of freedom throughout her life. **Above:** Her *Domestic Maxims* (1922) is a montage with a double impact, first as a collage, then for the added handwritten quotations from Arp, Baader, Hausmann, Huelsenbeck, Schwitters, and Serner. Having lived with Hausmann from 1915 to 1922, Hannah Höch was a close friend of Kurt Schwitters and Johannes Baader. Along with Sophie Taeuber-Arp, she was one of the two main women artists of Dada. Less famous Dada women were Emmy Hennings and Maya Chrusecz in Zurich, Gabrielle Buffet-Picabia in Paris and New York, and Else von Freytag-Loringhoven in New York.

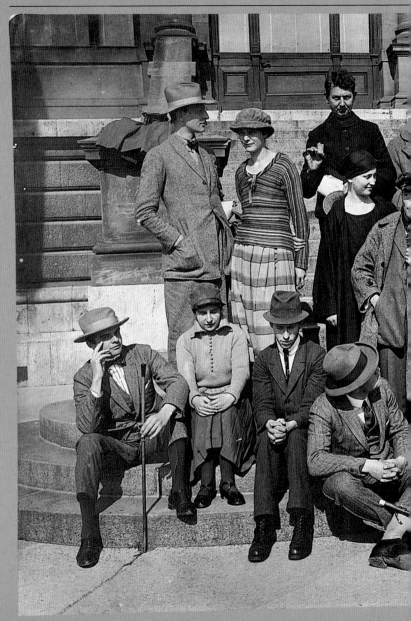

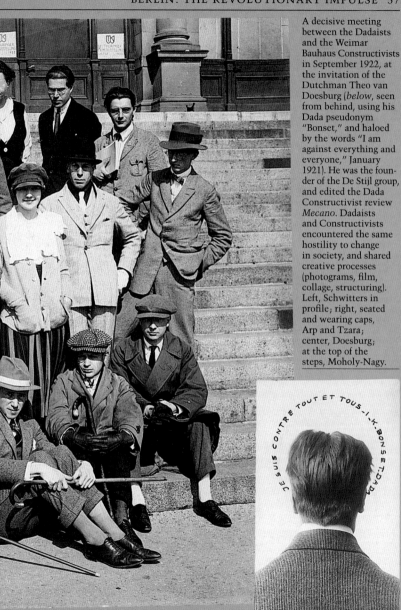

A decisive meeting between the Dadaists and the Weimar Bauhaus Constructivists in September 1922, at the invitation of the Dutchman Theo van Doesburg (*below*, seen from behind, using his Dada pseudonym "Bonset," and haloed by the words "I am against everything and everyone," January 1921). He was the founder of the De Stijl group, and edited the Dada Constructivist review *Mecano*. Dadaists and Constructivists encountered the same hostility to change in society, and shared creative processes (photograms, film, collage, structuring). Left, Schwitters in profile; right, seated and wearing caps, Arp and Tzara; center, Doesburg; at the top of the steps, Moholy-Nagy.

JE SUIS CONTRE TOUT ET TOUS – I.K. – BONSET-DADA

## Max Ernst and Johannes Baargeld in Cologne

The Cologne group, which consisted of Max Ernst and Johannes Theodor Baargeld, was formed after Max Ernst was demobilized. Ernst took part in the soldier-workers' insurrection in Brussels, and is even said to have shaken hands with Carl Einstein. He met August Macke (a Blaue Reiter artist from Munich) and Paul Klee. His first stay in Paris while on leave in 1916 determined the direction he would take in the future, and at the same time set him at a critical distance from the Berlin group. In particular, Ernst did not like Grosz. Although he exhibited at the First International Dada Fair, there is no doubt that he was very put off by the acerbic vein of Grosz's sketches, and that the "prettiness" of his own work led him straight into Surrealism.

The son of a major insurance agent in the Rhineland, Johannes Baargeld founded the Rhineland section of the Communist party and fought on both the artistic and political fronts. Along with Ernst, he published *Der Ventilator*, a high-circulation Communist magazine that was sold on the streets and at the gates of barracks and factories until it was banned by the British army, which occupied the left bank of the Rhine until 1926. It was *Der Ventilator* that published "Putsch in the Theater," an article about a "demonstration... against the clerical, chivalrous piece of tripe by a certain Mr.

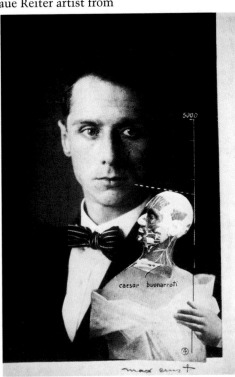

**Opposite page, top:** Drawing by Baargeld. His death while climbing a mountain in 1927 was always viewed as mysterious by Ernst.

**Above:** *The Punching Ball* or *The Immortality of Buonarroti*, also known as *dadafex maximus. Self-portrait of Max Ernst*, one of his rare photomontages.

Cohnen or Konen." The playwright was described as a "sort of ambitious Ash Wednesday herring from the same pond as the waxworks, Karl May, Lurley, and other fairground celebrities, given the hilarity that he has provoked," and the article expresses regret for having interrupted "the artistic and digestive sleep of the bourgeois." The theater, wrote *Der Ventilator*, "like every artistic embalming of a dominant class, lives and dies with those whom it embalms, with the hegemony of the class in question.

From this point of view, the artistic consumption of the bourgeois always has the same degree of maturity as its consumers."

## Dada Will Win

Despite British censorship, the group organized two exhibitions and published two magazines, *Die Schammade* and *Bulletin D*. The first exhibition, showing works by Otto Freundlich, Heinrich Hörle, and Franz Seiwert, was due to take place under the aegis of an arts society at the Art Club in 1919, but at the last minute their works were not accepted. As a result the exhibition was held in an independent venue, where the artists attracted much more attention than the arts society that had excluded them. The collector Katherine Dreier came to the exhibit and offered to show it in her

**Above:** *Die Schammade*, mechanical drawing by Ernst (signing himself as d'Adamax), with poems and works by Arp and Picabia, Baargeld, Serner, and Tzara.

own gallery in New Haven, Connecticut, but the authorities opposed this.

For the second exhibition, planned for April 1920 in the entrance hall of the Museum of Applied Arts, the group chose the title *Centrale W/3*. Since Arp was back in Cologne along with Baargeld and Ernst, there were now three artists, and "W" stood for West. This time the works by Ernst and Baargeld were taken down by the museum's director. The group riposted by showing them in the backyard of the Brasserie Winter in Schildergasse (Painter Street), which could only be entered through the men's lavatory. In the yard, the public was invited to destroy one of Ernst's works, a heavy block of wood that had an axe attached to it. Baargeld's "fluidoskeptrik" was an alarm clock in a tank filled with blood-red water, with some woman's hair floating on the surface. There were collages on the walls. The exhibit caused such resentment that it was pulled to pieces, and public indignation was so great that it was banned. The group was punished for its persistence by being charged with an affront to public decency.

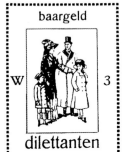

The reason given for this was a collage by Ernst that was declared pornographic: this was *The Word* or *Woman-Bird* (1920), composed of an engraving of *Eve* by Dürer (1504), into which Ernst inserted birds and an anatomical figure.

The exhibition re-opened, but without the engraving. Baargeld and Ernst printed

a poster that did not please the authorities any more than the woman-bird had; it read: "Dada will win! Re-opening of the exhibit closed down by the police. Dada is for peace and order."

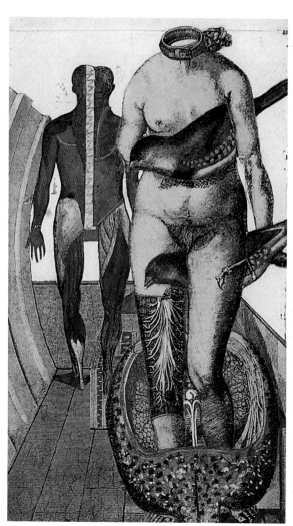

"The very sound of the word *duty* [*Pflicht* in German] has always filled me with horror and disgust. Futile things, on the other hand, transitory pleasures, giddiness, shortlived pleasures, rebellious and grandiloquent poetry, accounts of journeys real and imaginary, and everything that our teachers of morality call vain and our teachers of theology call the three sources of evil (pleasure of the eyes, pleasures of the flesh, the vanities of life) have attracted me, irresistibly.... My family forced me to pursue my studies, so I registered at the Faculty of Arts at Bonn University.... Close by there was... a clinic for the mentally ill, and the students were able to see an astonishing collection of sculptures and paintings by the unwilling inmates of this horrible place. They touched me to the quick, and disturbed me. I was tempted to see in them flashes of genius, and I took the decision to explore in depth the vague, dangerous areas that lie on the borders of madness."

—Max Ernst, "Rhineland Memories," 1956

**Left:** *The Word* or *Woman-Bird*, 1920

62

From its two poles of intensity, Zurich and Berlin, Dada spread to Paris in 1920, and also extended to the "free zones" of Barcelona, New York, Holland, and Tokyo, where Dada took off in sharply divergent directions, becoming an effervescent global network of free artists escaping from the control machine.

CHAPTER 3

# THE DADA DIASPORA

Dada spread as freely as dandelion spores in the wind. **Right:** Paul Citroën, "commissioner for Dadaist culture in Holland," writes to Picabia. **Opposite page:** The repetitive cover of *New York Dada* (April 1921), with an assisted "readymade" at the center, *Belle Haleine, Eau de Voilette* (*Beautiful breath, Veil water*), by Marcel Duchamp.

### *391*, from Barcelona to New York

In Barcelona in January 1917 (six months before the first issue of *Dada* in Zurich in July), the painter and poet Francis Picabia founded the magazine *391*, a "nomadic review" that went on to be published in New York and Paris. After spending a year in New York he found his life there exhausting, and in June 1916 came in search of the light and warmth of Barcelona. Another visitor to libertarian Catalonia was the inspired boxer-poet Arthur Cravan, who had become famous in Paris for publishing the arts magazine *Maintenant* there from 1912 to 1915. He met other exiles in Barcelona as well: his brother Otto Lloyd, Olga Sacharof, the Cubist painter Albert Gleizes, Marie Laurencin, and Robert and Sonia Delaunay (who later went on to Lisbon).

Also in Barcelona was the Russian Serge Charchoune, who created abstract painted films and exhibited with Hélène Grunhoff at the Dalmau Gallery, which also showed works by Picabia, Gleizes, and Torrès-Garcia. Josep Dalmau was an antique dealer and art lover who had lived in Paris for five years, exhibited works by the Cubists, and exhibited Marcel Duchamp's *Nude Descending a Staircase* after it was rejected by the Paris Salon des Indépendants in 1912.

The cover of the first issue of *391* showed a mechanical work by Picabia (*Novia*, 1917), and the inner pages included an attractive watercolor by Marie Laurencin and poems by Max Goth and Francis Picabia. It had just four pages. Picabia published four issues in Barcelona and took them with him to New York, where he brought out three issues during the summer of 1917. He published one issue in Zurich in February, after which *391* continued in Paris from November 1919 to October 1924.

Like Zurich, Barcelona was an oasis, and sometimes a port of call on the way

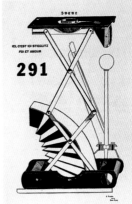

**Below:** Cover of the review *291* (nos. 5 and 6) with an opened camera, by Picabia (New York, July–August 1915) and Charchoune's poster for his exhibit with Grunhoff (Barcelona, April–May 1916), showing fascination with mechanisms and movement.

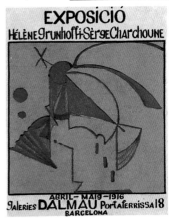

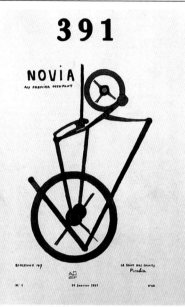

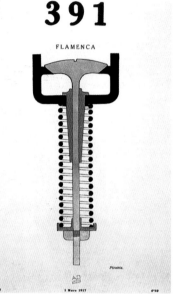

to New York. While he was there, Cravan gave up literature to teach boxing, run the Real Club Marítimo, and referee matches. In January 1916 he wrote to his friend André Level: "If I do perhaps have a little talent as a poet, it is because I have wild passions and immoderate needs; I would like to see the spring in Peru, to make friends with a giraffe, and when I read in the Petit Larousse that the Amazon flows for 6,420 kilometers and is the longest river in the world, that has an effect on me that I could not even describe in prose. You can see that it is better not to reason with me, especially since I realize that I am facing times of difficulty and even suffering, because I have no money. I shall always console myself with the thought that I am getting away from the Montparnasse district, where art now lives only by thieving, conniving, and trickery, where passion is calculated, where tenderness has been replaced by syntax and the heart by reason, and where there is not a single noble artist breathing and a hundred people are living by the new falsehood." On this

The title *291* was an homage to Stieglitz (his Little Gallery was at 291 Fifth Avenue), and the nomadic *391* was a reference to 291. Picabia's mechanical phase was his most authentically Dada period, at a time when he was determined to break away from painting's mainly psychological artifices. The artist's hand was still perceptible in the lines of *Novia*, but in *Flamenca* mechanical fidelity became impersonal and precise.

**Following page:** Poster for the boxing match between Johnson and Cravan, 1916; Cravan's description.

point Cravan was close to Tzara in his mistrust of the "modern."

## An Extravagant Demonstration of the Body

A legendary episode in the annals of poetry was the boxing match to which the boxer-poet Arthur Cravan challenged the heavyweight champion Jack Johnson. In Cravan's words, "genius is an extravagant demonstration of the body," "every great artist has a sense of provocation," and "all eccentricities of even a commonplace mind" are preferable "to the dull works of a bourgeois imbecile." To understand this match, however, it is essential to know that Johnson and Cravan had become friends in Paris boxing circles in 1914, and that Johnson, who became the first African American heavyweight champion in 1909, was in Barcelona because he had a difficult relationship with the United States. Jack Johnson was a provocation in himself, and a challenge to white America; for him, boxing was simply a metaphor for a black man who had decided to behave like a white man, refusing to accept the station in life imposed on his community. In 1904 he lived in California, in the white neighborhood of Bakersfield. It is hard to imagine today the appalling racism and vulgarity of the articles that were written about him at his moment of triumph. America wanted nothing more to do with him, nor did England.

Johnson and Cravan were destined to get on well together. The match in Barcelona was

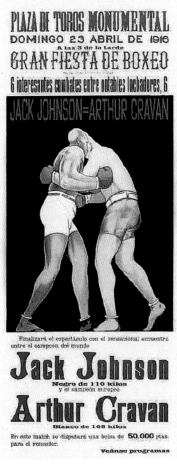

PLAZA DE TOROS MONUMENTAL
DOMINGO 23 ABRIL DE 1916
A las 3 de la tarde
GRAN FIESTA DE BOXEO
6 interesantes combates entre notables luchadores, 6
JACK JOHNSON=ARTHUR CRAVAN

Finalizará el espectáculo con el sensacional encuentro entre el campeón del mundo

## Jack Johnson
Negro de 110 kilos
y el campeón europeo

## Arthur Cravan
Blanco de 105 kilos
En este match se disputará una bolsa de 50,000 ptas. para el vencedor.
Véanse programas

Weight: 230 pounds. Height: 6 fee
broken nose. Distinguishing mann
Languages: French, English, Germa
Cravan, Dorian Hope, Sebastian H
Cooper, James M. Hayes. Known
critic, sailor, prospector, card sharpe

filmed for a full-length feature on Jack Johnson, and took place in front of four or five thousand people in the Plaza de Toros Monumental. The next day, however, (April 24, 1916), *La Veu de Catalunya* wrote: "From the first round, [Cravan] seemed very frightened. After tiring him out with a few exchanges of punches, the black man gave him three punches in the stomach that completely disorientated him. During the next five rounds, Cravan became completely exhausted, while the black man allowed himself to be punched for the benefit of the film that was being shot. In the sixth round, after literally 'playing' with his opponent, Johnson displayed overwhelming superiority. He gave him a jab from the right, followed by a hook which threw him to the ground and put him out of the contest. The black man then gave an exhibition with his trainers, and the celebrations ended." The press had heard that Cravan had a bet of 50,000 francs to cash in. "It was worth his while to get disfigured," wrote one journalist, while others referred to Johnson's "somewhat dubious and eventful life," and "the impresario's lack of scruple."

It is true that both men were short of money. Cravan left Barcelona for New York without delay. His legend would not have been quite complete had he not traveled on the same transatlantic liner as Trotsky, who wrote of meeting "a boxer, occasional literary hack, and cousin of Oscar Wilde's, [who] admitted frankly that he would rather demolish

Arthur Cravan was a free, passionate, fascinating man, and a poet whose legendary death on a "frail craft" in the Gulf of Mexico in the autumn of 1918 remains a mystery. A precursor of Dada, from 1912 to 1915 he single-handedly produced the magazine *Maintenant*, in which he displayed an independence of mind bordering on provocation with a vindication of his uncle, the great Oscar Wilde; a spoof interview with Gide; and a savage attack

on the modernist painters of the Salon des Indépendants. Cravan wrote under a variety of pseudonyms— "Californian orange-picker, Berlin chauffeur, burglar"— among others.

**Distinguishing Physical Characteristics:** glass eye, French accent. **Motto:** *"On ne me fait pas marcher moi."* **ted and Known Aliases:** Edouard Archinard, Isaac Holland, Robert Miradique, Marie Lowitska, W. **ons:** Poet, professor, boxer, dandy, *flâneur*, forger, **ack,** *bricoleur*, thief, editor, chauffeur.

the jaws of Yankee gentlemen in a
noble sport than have his ribs broken
by a German" (*My Life*, 1929).

## New York

In August 1915 Marcel Duchamp left a
France intolerant of a free man not engaged
in the world conflict, and went to New
York, where he had been famous since the
enormous impression created by his *Nude
Descending a Staircase* at the Armory
Show (1913). The exhibit revealed modern
art to the United States, and set off an
artistic revolution. A pre-Dada group was
formed: Arthur Cravan (newly arrived
from Barcelona); the American painters
John Covert, Joseph Stella, and Morton
Schamberg, who were influenced by
Duchamp and Picabia; and the photographer

Stieglitz and collectors Arensberg and Katherine
Dreier, who were to play a decisive role in the
history of modern art thanks to Duchamp. (The
1926 exhibit in Brooklyn of the Société Anonyme
collection, set up for Katherine Dreier by Duchamp,
would lead to the foundation of the Museum of
Modern Art in New York.)
   The war drove Picabia to New York at the begin-
ning of summer 1915. Since the Armory Show, he
already knew Stieglitz and Arensberg, Marius de
Zayas, and Paul Haviland. Everything that was
impossible in Paris would be possible in New York.
Picabia painted his "mechanical" works, whose
titles were a foretaste of the poetic works he would
create later when he went to Switzerland to meet
Tzara and Arp.

## The Light and Shadows of Man Ray

In March 1915 Man Ray, the "ray man," published
an issue of *The Ridgefield Gazook*. He had moved
in libertarian, anarchist circles in the American
sense of the word, as defined by Henry David
Thoreau (*Walden*, or *Life in the Woods*, 1854) and
Walt Whitman (*Leaves of Grass*, 1855). Living in the

artists' community of Ridgefield, New Jersey (1913–15), he discovered the work of poets William Carlos Williams, Mallarmé, and Rimbaud. He created the ten plates for his album of collages, *Revolving Doors* (1916–17), and became a photographer almost by accident, then made movies: *The Return to Reason* (1923), *Emak Bakia* (1927), *The Star of the Sea* (1928), and *The Mysteries of the Château of Dice* (1929).

This was a period of chance events and creativity that gradually took him into ethereal atmospheres that would then lead him toward rayograms, or solarizations. Appearances, shadows, and dust brought the two friends Man

**Opposite page, above:** A typical example of Duchamp's "infra-thin" aesthetic. *Dust Breeding* (left, photographed here by Man Ray), was created in New York in 1920, and is a detail of *The Bride Stripped Bare by Her Bachelors, Even*. Man Ray (above) became the eye of Dada and one of the great photographers of the century. The surviving records of the movement owe a great deal to his presence in New York and then Paris. With his black-and-white portraits of Kiki de Montparnasse, cinematographic superimpositions, solarizations, and objects and their shadows, Man Ray, as his name indicates, revealed photography to itself.

Ray and Marcel Duchamp together. *Dust Breeding* was later published in *Littérature* in Paris with the caption: "View from an airplane by Man Ray: Here is the estate of Rrose Sélavy/How arid it is. How fertile it is/How joyful it is. How sad it is." It was in fact Man Ray's photograph of a section of Duchamp's *The Large Glass*,

SEEING NEW YORK WITH A CUBIST

The Rude Descending a Staircase

placed on the ground under a low-angled light. Thanks to Man Ray, traces of Marcel Duchamp's life and actions still survive: a star-shaped patch cut into his hair in 1921, his disguises as Rrose Sélavy (the name is a pun for "Eros, That's Life!").

### *Fountain*: Duchamp's Readymade

Although Duchamp did not invent the readymade in New York—the first examples, *Bicycle Wheel* and *Bottle Rack*, date to 1913 and 1914 in Paris—it was there in 1917 that he created the one that had an irreversible historical impact: *Fountain*. What is a readymade? As its name suggests, it is an object that is already complete, ready for use, and chosen by the artist to be presented as a work of art. The concept not only radically questioned the meaning of a work of art, the criteria that governed its choice and recognition as art, the function of the museum or exhibit venue, and the very nature of human creation; it was also a provocation.

In the spring of 1917 Joseph Stella and Marcel Duchamp bought a porcelain urinal from J.L. Mott Iron Works, New York. A certain Richard Mutt from Philadelphia submitted this urinal, placed in the horizontal position as a work entitled *Fountain* and signed "R. Mutt, 1917," to the organizing committee of the Independent Artists' exhibit. Duchamp, who

**Above left:** Although Marcel Duchamp's *Nude Descending a Staircase* was caricatured by the professionals of denigration, here in the *Evening Sun* of March 20, 1913— "Seeing New York with a Cubist: The Rude Descending a Staircase. Rush Hour in the Subway"—at the Armory Show a miracle took place, and the *Nude* fascinated art lovers, some of whom stood in front of the canvas for hours. **Above right:** In Paris in 1914 Duchamp chose a bottle rack from the Hôtel de Ville general store as a work of art (*Bottle Rack*, 1906, replica belonging to Robert Rauschenberg). The term "readymade" came into being later, in the United States, in 1915.

since the Armory Show had become an authority in the United States, was a member of this committee and an artist whose work had always had great plurality of meaning. Quite apart from the concept of readymade, Mutt put to the test the freedom implied by the "no jury, no prize" system of the New York Independents, modeled on the Paris Indépendants' slogan, "ni jury ni récompense." Duchamp had not forgotten the rejection in 1912 of his *Nude Descending a Staircase*, at a time when he did not want to confront his fellow artists. The trap was now set, and predictably the Independents fell into it. The committee rejected *Fountain*, and Duchamp resigned.

Stieglitz's photograph of *Fountain* appeared in the second issue of *The Blind Man*, edited by Henri-Pierre Roché, Beatrice Wood, and Marcel Duchamp, with an editorial of several pages on the "Richard Mutt case": "Whether or not Mr. Mutt made the fountain with his own hands is of no importance. He CHOSE it. He took an article of life, placed it so that its useful significance disappeared under the new title and point of view—created a new thought for that object."

In her article "Buddha of the Bathroom," Louise Norton gave an aesthetic analysis of the object—the formal properties of the urinal and the pleasure it gave to the eye. The image of Buddha would be used again by Apollinaire in *Le Mercure de France*. *Fountain* disappeared; according to

"As for plumbing, that is absurd. The only works of art America has given are her plumbing and her bridges."
—from *The Blind Man*

**Below:** Duchamp, Picabia, and Beatrice Wood at Coney Island, 1917

# THE BLIND MAN

## The Richard Mutt Case

They say any artist paying six dollars may exhibit.

Mr. Richard Mutt sent in a fountain. Without discussion this article disappeared and never was exhibited.

What were the grounds for refusing Mr. Mutt's fountain:—

1. Some contended it was immoral, vulgar.

2. Others, it was plagiarism, a plain piece of plumbing.

Now Mr. Mutt's fountain is not immoral, that is absurd, no more than a bath tub is immoral. It is a fixture that you see every day in plumbers' show windows.

Whether Mr. Mutt with his own hands made the fountain or not has no importance. He CHOSE it. He took an ordinary article of life, placed it so that its useful significance disappeared under the new title and point of view—created a new thought for that object.

As for plumbing, that is absurd. The only works of art America has given are her plumbing and her bridges.

### "Buddha of the Bathroom"

Fountain by R. Mutt

Photograph by Alfred Stieglitz

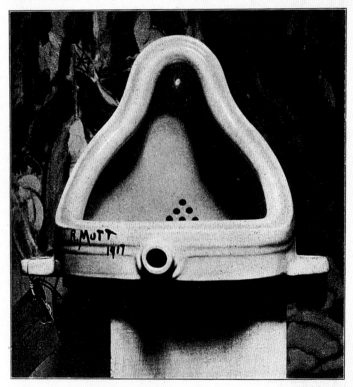

THE EXHIBIT REFUSED BY THE INDEPENDENTS

Préciser les "Readymades".

en projetant pour un moment ~~procha~~ à venir (tel jour, telle date telle minute )," d'inscrire un readymade." — Le readymade pourra ~~anananana~~ ensuite être cherché (avec tous délais)

L'important alors est donc ~~côté~~ + horlogisme, cet instantané, comme un discours prononcé à l'occasion de n'importe qui mais à telle heure. C'est une sorte de rendez-vous.

— Inscrire naturellement ~~cette~~ date, heure, minute, sur le readymade comme renseignements.

aussi le côté exemplaire du readymade

Readymade
→ Réciproque = Se servir d'un Rembrandt comme planche à repasser —

Duchamp gradually used his freedom to enrich the significance of the readymade, as explained in these notes. In 1961 he told Ulf Linde: "Dada was a negation and a protest. That did not particularly interest me. Individual negation only makes one dependent on what one is denying; collective negation means nothing. Dada was opposed to dead forms, but perhaps it was not worth making so much fuss about something that was already dead. My *Fountain* was not a negation; I just tried to create a new idea for an object that everyone thought they could identify. Everything can be something else, that is what I wanted to show."

rumor it was destroyed by William Glackens, the President of the Society of Independents, but it is also possible that, as Duchamp said one day, Arenberg bought it and then mislaid it. It is said that Duchamp and Man Ray were seen one last time carrying *Fountain* in public, and that the art lovers they walked past found the work deeply disturbing.

## Cravan: The Intoxication of Art

In New York, Cravan took to the arena once more, but this time for a lecture on art. In *391* Picabia announced that Cravan would "give lectures," and anticipated the event by speculating as to whether Cravan would come dressed as a man of the world or a cowboy, and predicting that he would choose the second and make an impressive entrance on horseback, shooting three times into the chandeliers with a revolver. In June 1917, Cravan arrived very late at the Grand Central Gallery for his own lecture and, as Picabia's wife Gabrielle Buffet-Picabia (herself a musician and excellent critic) wrote, he was seen "pushing his way through the large crowd of smart listeners. Obviously drunk, he had difficulty in reaching the lecture platform, his expression and gait showing the decided effects of alcohol. He gesticulated wildly and began to take off his waistcoat. A canvas by the American painter, Sterner, was hanging directly behind him, and the incoherence of his movements made us fear that he would damage it. After having taken off his waistcoat, he began to undo his suspenders." There

**Below:** In May 1919 Picabia drew a diagram of forces for *Dada 4–5*, after establishing the link between New York and Paris, but before the Paris phase of 1920. Tzara, Arp, Janco, and Duchamp set the clock at Dada time, along with the "precursors" (Cézanne, Mallarmé) and the *391* bell.

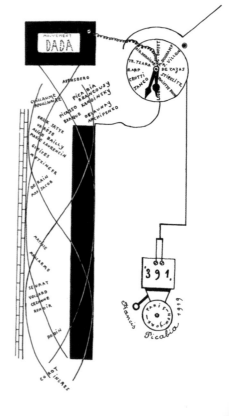

were vehement protests from the astonished audience, and just as the boxer-poet was hurling copious insults at the gathering, the police arrived and put him in handcuffs. "What a wonderful lecture! said Marcel [Duchamp], beaming, when we all got together that evening at the home of Arensberg." In New York the event was seen as a

second provocation, this time stirred up by Picabia to match Duchamp's glorious feat with *Fountain*.

## A Single Issue of *New York Dada*
In New York, Picabia continued to bring out *391*, which proved to be a highly imaginative magazine, with large pages and a variety of carefully chosen typographies that made each article distinctive. Picabia achieved the ambition that Tzara had written about in the "1918 Dada Manifesto": "Every page must explode, either with deep, heavy seriousness, or with a whirlwind, a giddy feeling, with the new or the eternal, with crushing wit or enthusiasm for principles, or with the way it is printed."

The review *391* was not the only Dada magazine that was published in New York, but it was the richest and most inventive. There was one issue of *New York Dada*, created by Duchamp and Man Ray. On the cover, the words "new york dada april 1921" were repeated, with an "assisted readymade" by Duchamp at the center: *Belle Haleine, Eau de Voilette* (or *Beautiful breath, Veil water*)(1921), which was a bottle of eau de toilette with a label

**Above:** The back cover of *391* often had Dada gossip. In June 1917 Picabia sent an amusing account of their friend Cravan's brief incarceration (see extract, left): "His delightful talk having been interrupted by unforeseen circumstances, the brilliant lecturer decided to end it at Sing-Sing, the summer rendezvous for fun-loving New Yorkers." In February 1920 the philosopher Henri Bergson's conversion to Dadaism was announced, along with that of the Prince of Monaco, and shortly after, that of Charlie Chaplin.

designed by Duchamp.

Here, the object was "assisted" by a photograph added as a medallion to the label, and showing Duchamp disguised as his alter-ego, Rrose Sélavy. Inside the magazine were works by Man Ray, Stieglitz, and Tzara. Man Ray summed the matter up in a few words: "Duchamp was in correspondence with the young group of poets and painters in Paris, the Dadaists, who asked us for contributions to their publications. Why not get out a New York edition of a Dada magazine? We went to work. Aside from the cover, which he designed, he left the rest of the makeup to me, as well as the choice of contents. Tristan Tzara, one of the founders of Dadaism, sent us a mock authorization from Paris, which we translated. I picked material at random—a poem by the painter Marsden Hartley; a caricature by a newspaper cartoonist, Goldberg; some banal slogans. Stieglitz gave us a photograph of a woman's leg in a too-tight shoe. I added a few equivocal photographs from my own files. Most of the material was unsigned to express our contempt for credits and merits. The distribution was just as haphazard, and the paper attracted very little attention. There was only the one issue. The effort was as futile as trying to grow lilies in a desert." Even so, the review published photographs by the great Stieglitz and by Man Ray (*Portemanteau*, also entitled *Dadaphoto*), poems by Baroness Else von Freytag-Loringhoven, an eccentric and captivating figure in the New York Dada circle, and an advertisement for the Société Anonyme's collection, designed by Kurt Schwitters.

This issue also contained a dazzling "Authorization," sent to the American group by the inventor of Dada. Duchamp had asked Gabrielle Buffet-Picabia to ask Tzara for "authorization to open a Dada branch in

Photographed by Man Ray, Marcel Duchamp as *Rrose Sélavy* (Paris, 1920–21). For Duchamp, this was a verbal, semantic, visual, polysemic game that kept going for years, right up to the aphorisms of the *Rrose Sélavy* collection (1939). This feminine alter ego had its opposite, the masculinized *Mona Lisa* (with added moustache, goatee, and saucy acronym L.H.O.O.Q., which when uttered sounded like "she has a hot ass"), which reflected an underlying erotic component of Duchamp's personality, as did the photograph of the assisted readymade, *Belle Haleine, Eau de Voilette* (*Beautiful breath, Veil water*), the perfume bottle on the cover of *New York Dada*.

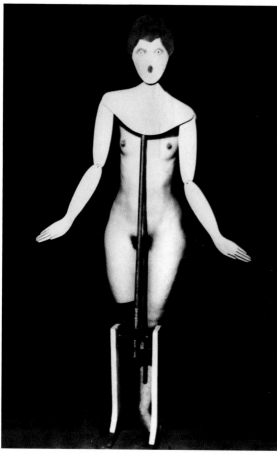

**Left:** *Dadaphoto* or *Portemanteau*, created by Man Ray for *New York Dada* (April 1921). Man Ray wrote to Tzara that New York was Dada, would tolerate no rival, and would not notice Dada. Dada must remain a secret, he concluded. Indeed, apart from the fact that New York played a decisive role in the recognition of modern art (from the Armory Show to the Museum of Modern Art), Dada there was an adventure among a circle of friends. **Below:** Else von Freytag-Loringhoven, December 7, 1915. According to *Little Review*, she formed a "mystic" link between Paris and New York.

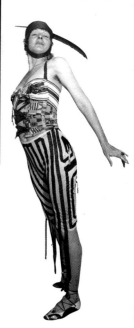

New York." Was he setting a trap for Tzara as he had done for the Independents? It was, after all, Tzara who had decreed that all Dada members shared the position of president. "Dada," replied Tzara, "is neither a dogma nor a school, but rather a constellation of free individuals and facets." Unlike Huelsenbeck he recognized any artist who joined the movement as a Dadaist, with no need to pass any other kind of test. *Quod erat demonstrandum.*

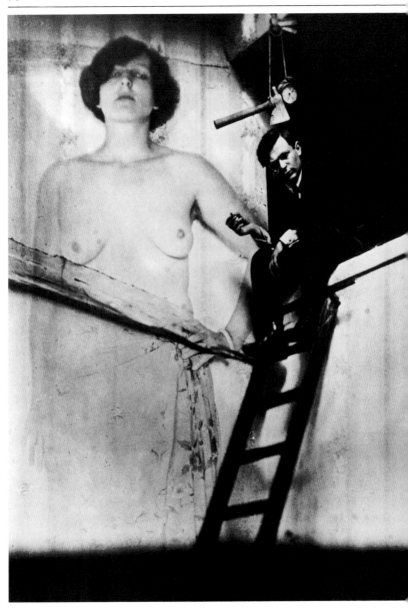

The armistice in 1918 coincided with the death of Guillaume Apollinaire; the avant-garde descended into gloom. Tzara was called upon, and in 1920 Paris created a new version of Dada, with the emphasis on the ideological perspective that would shape a group of anti-establishment intellectuals who would later, in 1924, become the Surrealists. A literary and polemical form of Dadaism now took over from the aesthetic and cultural revolution of the founding nucleus in Zurich.

CHAPTER 4

# PARIS: THE AESTHETIC COMPROMISE

**Left:** "Tzara under the ax" (Paris, October 1921, at Duchamp's apartment, 22 rue La Condamine, 17th arrondissement) is one of the few montages by Man Ray (superimposed is Duchamp's girlfriend, Madeleine Turban) for a personal exhibit organized by Max Ernst in Cologne in November 1921.
**Right:** Picabia, *Beware of Painting* (ca. 1919).

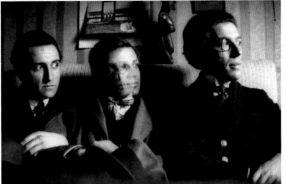

**Left:** An alert, doubtful Jacques Rigaut; a blurred Tzara moving his head; Breton sculpted and hieratic, gazing into the future. Rigaut would later write a short news item: "Yesterday the corpse of Dada was found in the garden of the Palais-Royal. It was presumed to be a suicide (since the poor wretch had been threatening to take its own life since it was born) until André Breton made

If Picabia had not gone to Switzerland in January 1919 to meet Dada, and if Tzara had not come to Paris early in 1920 at the invitation of Picabia and Breton, Dadaism might not have been known to posterity as anything other than a small group of artists in revolt in the neutral oasis that Zurich had been (Joyce wrote *Ulysses* there), and an intense moment in history, mingled with the artistic and political history of a Germany in decay.

In the 1920s, however, Paris was, in Joyce's words, a "light for lovers in the forest of the world," and a "moveable feast" for Hemingway. Artists and writers came there from all over the world, some famous and some unknown, from Gertrude Stein to Picasso, from Picabia to Pansaers, from Arp to Huidobro. In a Paris wounded by a war that had taken away the freedom of the past ("the world of yesterday," as Stefan Zweig called it), Dada had a second wind and created a worldwide impact that followed on from Tzara's intense activity in Zurich. Nevertheless, this "recognition for Dada," as Jacques Rivière described it in the *Nouvelle Revue Française*, was not without cost, since it later led to a historic misunderstanding, whereby Dada would be systematically confused with the movement that was founded on its ruins, having all but banished it or even killed it off: Surrealism.

a full confession."
At the Barrès trial he would say: "Revolt is a form of optimism barely less repugnant than the current optimism."

**Opposite page:** some friends at the Dôme, carrefour Vavin, including Tzara at the center and Kiki de Montparnasse on the right.

## Automatic Writing

It was the young writer André Breton who, rightly fascinated by the freedom that Tzara spoke of, especially in the "1918 Dada Manifesto," contacted him in Paris. Shortly before Tzara's arrival, Breton and his friends Aragon and Soupault had founded the review *Littérature* which, given its conventional typography, was by no means a Dadaist magazine. Its content was cautious, and it had the backing of great literary figures (André Gide, Paul Valéry, Jean Paulhan, Léon-Paul Fargue, Paul Morand, Mallarmé, Jules Romains) in whom Tzara and Picabia had no interest.

Fascinated by Tzara's poetic élan (*La Première aventure céleste de Mr Antipyrine*, *Vingt-cinq poèmes*, or his "complete circuit by the moon and color"), Breton and Soupault had taken up the automatic writing technique already used in Zurich by Arp, Serner, and Tzara, and in about ten feverish days had produced a founding work, the *Champs magnétiques* (Magnetic fields). Even before Tzara arrived, Breton and Soupault had been influenced by his writings and had called on the resources of the subconscious with which, five years later, Surrealism would have a field day.

It was no doubt in overestimating this reservoir of the subconscious that Surrealism made its

**Opposite page:** *Dada 4–5* (Zurich, May 1919) celebrated the meeting of Tzara, Arp, and Picabia.

"[Picabia] came as an emissary from the American Dadaists to salute his fellow members in Zurich. Tristan Tzara and I were curious and excited, and went to his hotel. We found him busy dissecting an alarm clock. I couldn't help thinking of Rembrandt's *Anatomy*....Even so, we had progressed a long way toward abstraction. Pitilessly he slashed his alarm clock to pieces, right down to the spring, which he pulled out triumphantly. Interrupting his work for a moment, he greeted us, and without delay took the wheels, spring, hands, and other secret parts of the clock, and stamped them on to pieces of paper."

—Jean Arp

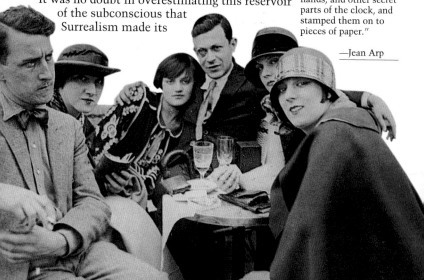

fundamental mistake. Tzara had only a limited interest in it, and saw in this attraction to the unconscious mind a facile sentimentality that he feared more than anything else in literature. He treated language as a physical medium, in the same way as the painters, sculptors, photographers, and filmmakers in Zurich operated on their materials in a concrete way, cutting them up, mounting, and sticking them, and thus achieving what Picasso regarded as "the pinnacle of reality."

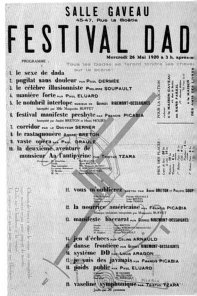

### Dada Headquarters
The Picabias' apartment on rue Emile-Augier, where Tzara came to stay in January 1920, became the headquarters of Dada. Tzara and Breton launched Dada in Paris. Right away they changed a meeting already scheduled in *Littérature* (January) to a Dada matinee, and improvised a soirée at the Salon des Indépendants at the Grand Palais on the Champs Elysées in February. In March, the first Dada shows took place at the Maison de l'Oeuvre (in the Lugné-Poe theater) with performances of plays including *Dumb Canary* by Georges Ribemont-Dessaignes.

### The Dada Festival
On May 26, 1920, the Dada Festival in the Salle Gaveau on rue La Boétie gave the movement a great deal of publicity, not least because the occasion was marked by a special issue of *Littérature*, published under the title "Twenty-three Manifestoes of the Dada Movement." Dada was launched. "We are at the Dada Festival," wrote a journalist, "and all those present have bright, impatient eyes and quivering feet. They are awaiting a real treat in the best of taste." The Paris smart set was out in force. Dada was now a world event.

Georges Ribemont-Dessaignes performed his "Danse Frontière" wearing a large cardboard funnel

Etienne Gaveau became nervous when he saw his Salle Gaveau accepting items with titles such as "sodomist music" (Picabia *The American Nanny*), and opposed the distribution of the handbill, demanding assurances that the movement would respect the proprieties of a "decent, well-bred public." The organizers made whatever promises were necessary, and the program was publicized by men with sandwich boards. This was the most turbulent of all the Dada performances.

**Above right:** *The Oceanic Sentiment* by Ribemont-Dessaignes; **Opposite:** Breton wearing a slogan by Picabia: "In order to love something you need to have seen and heard it for a long time bunch of idiots."

oscillating on its tip. Tzara's "Vaseline Symphonique" was performed by twenty people. "Its performance caused some internal difficulties," as Ribemont-Dessaignes recalled in *Déjà jadis* (Already in the past). "Highly unmusical though it was, it encountered open hostility from Breton, who both hated music and was far from proud to be reduced to the role of a performer, in this case playing an instrument or singing in the choir."

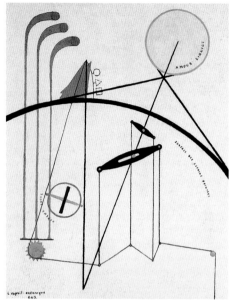

The rest of the show consisted of a sketch by Breton and Soupault, "You Will Forget Me," a piece by Louis Aragon called "System DD," and contributions by Picabia, Dermée, Arnauld, and Eluard. On the great organ in the Salle Gaveau, normally used for Bach, a fashionable foxtrot called "Pelican" was played.

The newspapers exploded with trivial comments. While still in Zurich, Tzara had already written to Picabia: "I imagine that idiocy is the same everywhere because everywhere there are journalists." Some reactions were: "Boche Dada, cheval de Troie moderne" ("Hun Dada, the modern Trojan horse," the headline in *Le Phare*, Nantes, April 26), "Une douce folie, le dadaïsme" ("Dadaism, a mild madness," *L'Avenir du Puy-de-Dôme*), "Dada et poires" ("Dada and suckers," *La France*), "Dada ou le triomphe du rien" ("Dada or the triumph of nothing," *Echo de Paris*), "Timbres et timbrés" ("Tones and

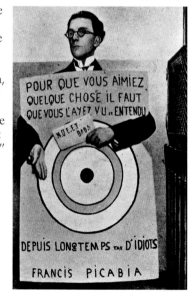

head cases," *La Liberté*), "The Gagas" (*L'Echo de Paris*, signed AB), "Herr Dada" (*Les Nouvelles*, Bordeaux). Greatly vexed, *Le Petit Parisien* lamented: "DADA. They roared, caterwauled, and barked, but they did not get their hair cut."

Even Courteline was asked what he thought, between two games of bridge: "They should all be burned on the public square, their exhibits should be damn well set on fire, and their performances of wild, unwholesome imaginings should be banned. The people at the head of this Dada movement are peddlers of insanity, dealers in madness."

*L'Eclair* asked: "Did you know that there was a Dada movement? It is not, as one might think, a society for the improvement of horse breeding, but rather a company aiming for the stupefaction of the human race....I hear that compared to them, Picasso is a nauseating classicist, a pompous old-timer, a sort of Ingres."

**Maurice Barrès on Trial**

In the spring of 1922, Dada put the academician and parliamentary representative Maurice Barrès on trial, accusing him of an "attack on the safety of the mind." With its public announcements, posters, and written records of the hearing, this mock-up bore a remarkable resemblance to a real trial, and divided opinion among the Dadaists. Tzara, Picabia, Georges Ribemont-Dessaignes, Erik Satie, and Pansaers did not much like the idea of a tribunal, particularly a revolutionary one. Tzara stuck to his role as catalyst, and merely observed. For him, after all, everyone was president of the Dada movement. He, the founder, only took part as a "witness," and left it to Breton to direct his trial, which was a response to the fact that Barrès, as a patriot, nationalist, and "anti-Dreyfusard," had denied having had anarchist-socialist tendencies in his youth. The aim was to examine the evolution of any revolutionary position, but Barrès meant nothing to Tzara. The trial was

**Above:** The Barrès Trial on May 13, 1921: from left to right, Louis Aragon, Pierre Deval, André Breton, Tristan Tzara, Philippe Soupault, Théodore Fraenkel, the dummy of Barrès, Georges Ribemont-Dessaignes, Benjamin Péret, Jacques Rigaut, René Hilsum, and Serge Charchoune. The trial was not just a Dada parody; André Breton even asked a journalist from the right-wing press, *Action française*, to take part, but he refused vehemently.

farcical; Breton was the presiding judge, Ribemont-Dessaignes was a bizarre public prosecutor, and Aragon and Soupault were the counsels for the defense. Jacques Rigaut was a witness, but refused to take the oath. At a time when France was divided by a public debate about whether or not an unknown soldier should be buried under the Arc de Triomphe, Benjamin Péret burst in as an unknown soldier in a gas mask, and interrupted the tribunal in German. Threats were made by patriots who somehow found out about this, and Benjamin Péret prudently withdrew from the scene. Tzara brilliantly held the venture up to ridicule: "I have no confidence in justice, even if it is justice done by Dada. You will agree with me, your Honor," he said to Breton, "that we are all just a bunch of bastards, and that as a result little differences between big bastards and smaller bastards are of no importance."

The trial was beginning to slip out of Breton's control, and in desperation he shot a question at Tzara: "Does the witness wish to be taken for a complete imbecile, or is he trying to get himself locked up in a mental hospital?" Tzara knew exactly

Tzara went out of the room, slamming the door. Picabia left with his friends when Aragon began a speech for the defense, described by Soupault as "skilful and brilliant," which delivered "a condemnation of the tribunal more than a defense of the accused." The jury sentenced Barrès to twenty years' hard labor. We know from *Littérature* that at the moment the usher called out, "Are you there, Barrès?" the nationalist writer was "holding forth in Aix-en-Provence on the subject of the French spirit during the war. A few young provincials listened open-mouthed to the academician and parliamentary representative from Paris."

what he wanted to say: "Yes, I do wish to be taken for a complete imbecile, and I am not trying to escape from the asylum in which I live my life." In a sense, there was no more to be said between Breton and Tzara. Dada clearly had no intention of recovering from the "pure idiocy" that it called for.

### Dada Max Ernst: A Private Viewing at the Sans Pareil

A few days after the Barrès Trial, on May 2, 1921, an exhibit of works by the painter Max Ernst (Cologne Dada group) took place at the Sans Pareil bookstore under the title *La mise sous whisky marin* (The placing of whisky marine). It consisted of small-format works that Dadamax had been able to send, numbered by means of bus tickets: drawings known as "peintopeintures," which included the *hyperborean overseas boophile plantation*, "fatagagas" (a sort of acronym for "fabrication of paintings guaranteed gazometric") in collaboration with Arp or Baargeld. Works with "poetic" captions: "the refrigerated gas pipe grows small crackling numbers/the compressed heart has run away in time/we are leaning against the Delphic bay tree."

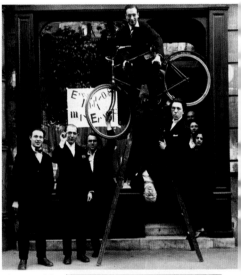

In front of the bookshop a happening was improvised in homage to the absent painter, who could not be there owing to obstructive red tape that prevented him from getting a visa. Max Ernst was a francophile who had no connections with the Berlin group, and would be the pivotal link between Cologne Dada and Surrealism in Paris. The poet Clément Pansaers, who was an informed onlooker thanks to his friendship with Carl Einstein, was perplexed by

**Below:** At the Sans Pareil—a free publishing concern—a playful protest against the arbitrary ruling that had prevented Max Ernst from coming to Paris: the founder René Hilsum, Benjamin Péret, Serge Charchoune, Philippe Soupault on the ladder carrying a bicycle, Jacques Rigaut hanging upside down, André Breton on the first rung of the ladder.

les dames sont priées d'apporter sous leurs bijoux

AU SANS PAREIL,
37, AVENUE KLÉBER
PARIS 16e

VOUS N'ÊTES QU'E DES ENFANTS

du 3 mai au 3 juin

# EXPOSITION DADA
# MAX ERNST

dessins mécanoplastiques   plasto - plastiques   peinto-
peintures anaplastiques anatomiques antizymiques aéro-
graphiques antiphonaires arrosables et républicaines

*ENTRÉE LIBRE        SORTIE FACILE*
mains dans les poches        tableau sous le bras

## AU-DELA DE LA PEINTURE

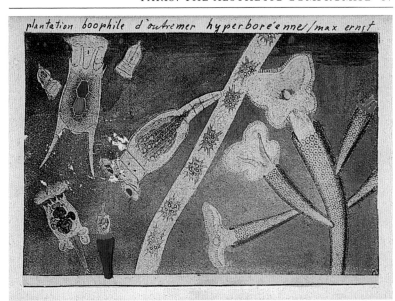

plantation boophile d'outremer hyperboréenne/max ernst

this regression: "Was it just as a con trick," he wrote, "that the French Dadaists recently showed the work of the German Max Ernst in Paris, and announced him as a phenomenon and the revelation of the new painting of tomorrow, when in fact, apart from a few amusing little things, there is nothing to him but an overrated formula that is already long out of date?"

**Open Disagreement with the "Man from Nowhere"**
At the beginning of 1922, the emergence in public of a fundamental difference of opinion meant that the now-open conflict between Dada sympathizers and Breton's modernist tendency was irreversible. In February, the editor of *Littérature* planned a "Congress for the determination of the directives and defense of the Modern Spirit," and formed an (over-)eclectic committee with Fernand Léger, Amédée Ozenfant, Robert Delaunay, Georges Auric, Jean Paulhan, and Roger Vitrac. Tzara was reluctant to join this kind of coterie: "I consider that the

**Above:** Max Ernst, *Hyperborean Overseas Boophile Plantation*, 1921, engraving with drawing and water-color. Dada's invitation to the private viewing on May 2. **Opposite page:** "at 10 P.M. the kangaroo, 10:30 P.M. high frequency, 11 P.M. distribution of surprises, starting at 11:30 P.M. private lives/Dada season."

"What the newspapers accuse me of is not true. I have never used abdo-minal surface images to increase the luminous effect of my paintings. I limit myself to using rhinocerosized belch tongs."

—Max Ernst, 1920

current stagnation, resulting from the mixing of tendencies, the confusion of genres, and the replacement of individualities by groups, is more dangerous than reaction." This time the split that Tzara had dramatized with brilliant irony at the Barrès trial would turn into public hostility.

Breton was furious, and gave the weekly magazine *Comœdia* a press release, at the bottom of which he named signatories who had not been consulted, continued to make vague accusations against Tzara and against the "schemes of an impostor eager for publicity." Defenses were mustered at the Closerie des Lilas, where the avant-garde collectively distanced itself from the "ridiculous bureaucratic preparations" for the Congress. Breton was disowned, and Erik Satie now regarded the members of *Littérature* as "faux Dadas."

Despite promises of life-long friendship, from now on Tzara—whom William Burroughs would call "the man from nowhere"—was treated as an isolated figure, whom Breton resented as a threat to his ventures. At the time, Aragon did not want to disavow his friend Breton, but in the 1970s he agreed

"Doesn't it seem rather funny to you that the public should be warned against my actions (!) a few days after my rejection? An international Congress that condemns someone for being a foreigner; an organizing committee that takes the liberty of making critical judgments (the Dada movement does not correspond to any reality); these are commercial enterprises that do not have the right to 'define the scope of modernism.' And that's quite apart from the ridicule that such an idea may attract."

—Tristan Tzara to the newspaper *La Liberté*

**Above:** Tzara, wearing a monocle, in front of objects by Man Ray.

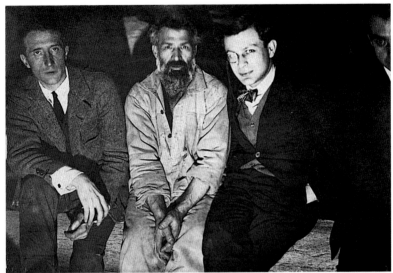

that "By opening up the internal discussions of the Dada team to a crowd of men and women, both journalists and artists, with no regard for what we thought of it, in order to achieve a sort of democracy of modernism, Breton was fundamentally going against Dada policy, after eighteen months of exercising it."

### "Dada Is Not Modern at All"
Although the end of Dada did not take place officially until the summer of 1923, for Tzara something was already ending earlier, in any case by the fall of 1922, when at his "Lecture on Dada" (September 1922 in Jena, where he narrowly escaped physical violence from extreme right-wing students), he proclaimed the death of Dada and reaffirmed his hostility to modernism: "Dada is not modern at all, it is rather a return to a quasi-Buddhist religion of indifference. Dada puts an artificial sweetness onto things, a snow of butterflies coming out of a conjurer's skull. Dada is stillness, and does not understand the passions. You will say that that is a paradox, because Dada manifests itself in violent acts. Yes, the reactions of individuals contaminated by destruction are quite

Marcel Duchamp, Constantin Brancusi, Tristan Tzara, and Man Ray in 1924. As an open, fragmented diaspora, Dada was a platform on which the many different variations of Dada and Dadaism intersected. The sculptor Brancusi, who, like Tzara, was Romanian, formed a lasting friendship with Duchamp. Brancusi had, after all, defined Dada better than anyone when he declared that the difficult thing was not making things, but putting oneself in conditions in which one could make them. If there is a Dada legend, it is not so much to do with the works themselves as with the emergence of those conditions.

violent, but once those reactions are exhausted and wrecked by the Satanic insistence of a continual and growing 'what's the point,' what remains and dominates is indifference. I could also support the opposite opinion with the same tone of conviction. I admit that my friends do not approve of this point of view."

### The Delicious Fields

In 1922, Tzara wrote a preface to the photograms of Man Ray, who had come over from New York during the summer of 1921, and made it clear that he was taking a different direction from the aesthetic of Max Ernst. *The Delicious Fields*, whose title echoed *The Magnetic Fields*, consisted of twelve rayograms created by printing directly on the bromide photographic paper in the darkroom. Tzara's preface was a critical declaration relating to modern painting in Paris, emphasizing the importance of the discovery of the material and its beauty as a "physicochemical product."

"The painters saw that," wrote Tzara, "they sat in a circle, had long discussions, and discovered the laws of decomposition. And the laws of construction. And convolution. And the laws of intelligence and understanding, of selling, reproduction, dignity, and museum conservation. Then others came along with enlightened cries, and said that what the first ones had created was nothing but bird dirt. They offered their merchandise in its place, an impressionistic working drawing reduced to a vulgar but seductive symbol. For a while I believed in their idiotic cries, washed clean by melted snow, but I very quickly realized that they were tormented by nothing but sterile jealousy."

### The Bearded Heart Soirée

At Tzara's invitation and using a small automatic movie camera that could contain no more than about a meter of film, Man Ray created a short masterpiece for the Bearded Heart soirée (July 6,

"I turned on the light. Before my eyes, an image was taking shape. It was not quite a simple outline of the objects; they had been bent out of shape and refracted by the lenses, which had been more or less in contact with the paper, and the part that was directly exposed to the light stood out from the black background, as if in relief. I remember when I was a child, having put some ferns into a little printing frame. By exposing them to sunlight, I got a white negative of my ferns. As well as my Rayographs...there was a three-dimensional effect and a whole range of values."

—Man Ray, *Self-Portrait*, 1963

**Above and right:** Rayograms from *Champs Delicieux* (The delicious fields), 1922

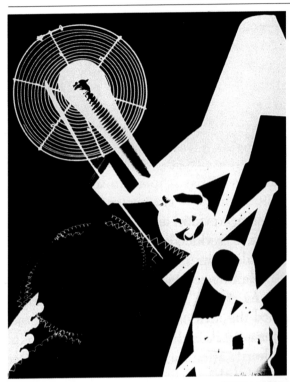

Tzara had a passion for discovery. "It is the purest Dada," he said to Man Ray, "and much better than the similar attempts— simple impressions of flat shapes in black and white—made some years before by Christian Schad, a Dadaist in the early period." Tzara wrote a preface for *Les Champs Delicieux*: "Is it a spiral of water or the tragic gleam of a revolver, an egg, a sparkling arch or a blockage of the reason, a subtle ear with a mineral whistle or a turbine of algebraic formulae? As the mirror throws back the image effortlessly, and the echo throws back the voice, without asking us why, the beauty of the material belongs to no one, because it is now a physicochemical product."

1923). This was *Return to Reason*, which he made by working in the darkroom on about thirty meters of virgin film, throwing pins and thumbtacks onto it at random, and then mixing these sequences with images filmed earlier.

Given the circumstances, however, the soirée at the Théâtre Michel took an unexpected turn that would plunge a predictable split between Dada and the future Surrealists into physical violence. The *Littérature* group was in the middle of its "hypnotic sleeps" period. An article by Breton, "Entrance of the

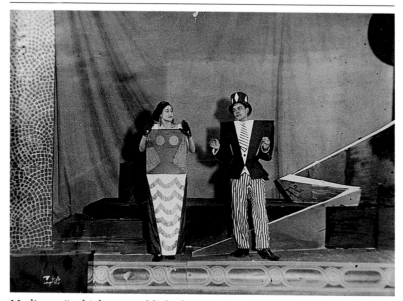

Mediums," which was published in *Littérature* in November 1922, provoked nothing but sarcasm from the Dadaists on account of its drift towards spiritualism. Breton, who claimed to be more Dadaist than Dada itself, adopted a suicidal position. Echoing the stance taken by Marcel Duchamp when he gave up art after putting the finishing touches to *The Large Glass*, he claimed that he was giving up writing; would have nothing more to do with reviews, books, and newspapers; and did not wish to continue publishing *Littérature*.

The break between Tzara and Breton could not have been more complete. Meanwhile Tzara was working at full stretch. He put on a new performance of his play *The Gas Heart*, which had already been played at the Dada Salon in 1921.

The Constructivist Theo van Doesburg created scenery for the dances of Lizica Codreanu, who performed poems in transrational language (Zaoum neologisms) by the Russian Futurist Zdanevich, wearing costumes by Sonia Delaunay. Abstract films by Man Ray, Hans Richter (*Rhythm 21*), and

"EYE: Easter vertebrates in military cages painting does not interest me much. I like muffled wide landscapes gallop. NOSE: Your play is charming, but no one understands a word of it." Jacqueline Chaumont (Mouth) and the poet René Crevel (Eye) on stage in July 1923. An admirer of Tzara's since 1918, Sonia Delaunay designed the costumes. The violence and disruption drew attention away from the beauty of *The Gas Heart*, a powerful work that Tzara, after his time in the French Resistance, put on in 1946, in a book printed by Guy Lévis-Mano.

Charles Sheeler (*New York Smoke*) were shown, and music by Georges Auric, Darius Milhaud (a shimmy entitled "Soft Caramel"), Erik Satie, and Igor Stravinsky was performed.

When the evening was sabotaged by the Breton group, this marked the end of Dada in Paris. The organizers had left it up to Marcel Herrand to choose the poems (by Apollinaire, Baron, Jean Cocteau, Paul Eluard, Philippe Soupault, and Tzara). For Eluard, who was hostile toward Cocteau, that was a good enough excuse to try to prevent *The Gas Heart* from happening. He was joined by several others. Breton broke Pierre de Massot's arm onstage. The police threw Breton, Desnos, and Péret out. In *Nadja* (1928), Breton claimed that it was Tzara who had called the police, but he later withdrew this accusation. When Man Ray's film *Return to Reason* was broken, more fighting broke out in the darkness. After the curtain rose on *The Gas Heart*, Eluard demanded an explanation from Tzara for Breton's ejection, and punched Tzara and Crevel in the face. The stage crew took Tzara's side and tried to shield him from Eluard, who in turn was manhandled.

Handbill for *Le Coeur à barbe* (The bearded heart), created by the Russian Futurist poet Ilya Zdanevich (Iliazd), founder of "Degree 41." He punctuated the typography with large and small images, as in *Ledentu Le Phare*, his 1923 "Zaoum" masterpiece. "In Zaoum," wrote Ribemont-Dessaignes,

## Instantaneism versus Surrealism

It was this confusion, denounced by Tzara as worse than reaction, that finally brought an end to the Breton group's friendships with him, and the struggles they had undertaken since 1920. The freedom of thought opened up by Dada was no longer popular; it was becoming a threat to building a career. As early as the summer of 1920, at the time when Breton was publishing an article about Dada in the *Nouvelle Revue Française*, and correcting the proofs of Marcel Proust's great work, the Sans Pareil became concerned about the manuscript of Picabia's *Jesus*

"every word has several more or less emphatic meanings of different types and on different levels, concrete or abstract, particular or general." In 1949 Zdanevich's anthology *Poetry of Unknown Words* retraced the history of verbal innovations from Khlebnikov to Dada.

*Christ, the Flashy Foreigner*, and refused to publish it unless he made some changes. Breton, meanwhile, cautiously withdrew his offer to write a preface.

The French phase of Dada, led by Breton, turned into Surrealism, with a few notable exceptions, such as a performance of Tristan Tzara's *Mouchoir de nuages* (Handkerchief of clouds), which brought about the beginnings of a reconciliation in May 1924. The passionate issues that were so dear to the future Surrealist group were not always easy to follow, however. Forces were regrouped. Tzara brought out one volume of all his manifestoes, which previously had been scattered around various reviews; the *Seven Dada Manifestoes* were published by Budry in July 1924.

Breton formed around him a new version of the group and the magazine *La Révolution surréaliste* (Pierre Naville, Benjamin Péret). Aragon wrote "Une vague de rêves" (A wave of dreams), anticipating Breton's "Surrealist Manifesto," which would be printed that November. It marked a noticeable change of style, since while the Dada manifestoes were truly Dadaist, the "Surrealist Manifesto" was not Surrealist; it set forth a literary theory, in language that was superb but conventional.

Exasperated and ironic, Picabia launched a new "ism" known as "Instantaneism" in the last issue of *391*, which marked the performance of his ballet *Relâche* (*No Performance Tonight*) by the Swedish Ballet, with music by Erik Satie ("Obscene Ballet"). Picabia made it very clear which side he was on: "As for Tzara, he wrote some extremely personal works in Switzerland which Breton drew on without scruple.... He tried to arrange the Dada affair in the way that was most advantageous to him, and above all, least embarrassing.... The works of Messrs Breton and, what's his name? Philippe Coupeaux, I think, are a poor imitation of Dada, and their Surrealism is of exactly the same order.... Breton is an actor who wants all the leading

Picabia, no doubt because he had gone to meet Dada in Zurich, was deeply offended by the blow that was struck at Tzara in order to depose him. While Dada mistrusted "isms," he launched Instantaneism to mock Surrealism for its ambition to be a new label and represent itself as a historic milestone. Ten years older than the Surrealists and a close friend of Apollinaire, the Duchamp brothers, and Georges Ribemont-Dessaignes, Picabia reaffirmed the moment

and the here and now, rejected the future and the idea of great men, and believed only in life.

**Page 96:** *P*, collage by Raoul Hausmann, 1921

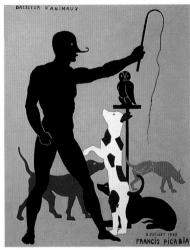

roles in the theater of illusionism, and is no more than a poor man's Robert-Houdin [a famous magician at the time]." Once again the avant-garde was not fooled.

## "A Spiritualist Trick"

The creationist poet Huidobro, who was close to Dada, wrote that the Dadaist manifestoes "are much more Surrealist, at least in their form, than the Surrealist manifestoes." The creationist declared, "If your Surrealism claims to make us write automatically, like a medium, at the speed of a pencil on a motorcycle track, without the deep interplay of all our faculties under pressure...your poetry is inferior in both its source and its methods. You lower poetry to the banality of a spiritualist trick."

The die was cast. The period saw the beginnings of an inexorable return to order in the 1930s. A Surrealist group and review *La Révolution surréaliste* established Surrealism as a unifying group built on the obliteration of Dada, creationism, *391*, and pure plastic art. Dada would re-emerge later through Merz, the New Realism, Fluxus, Allen Ginsberg, William Burroughs, and all the living creative processes of the twentieth century.

Picabia's rage in November 1924: "André Breton is not a revolutionary, this figure cannot belong to the avant-garde.... Never having lived, this artist is the typical petit bourgeois who loves little collections of paintings; he hates traveling, he only likes his coffee.... Beware, young poets; André Breton is not playing for the sake of the game, but for the sake of greed. He thinks that if one day he has enough savings and a good memory, he will be able to become a great man."

**Above right:** *Animal Trainer* by Picabia, 1923; **Above left:** *Tableau Rastadada*, a rare German-style photomontage by Picabia, dedicated to Arp and Ernst.

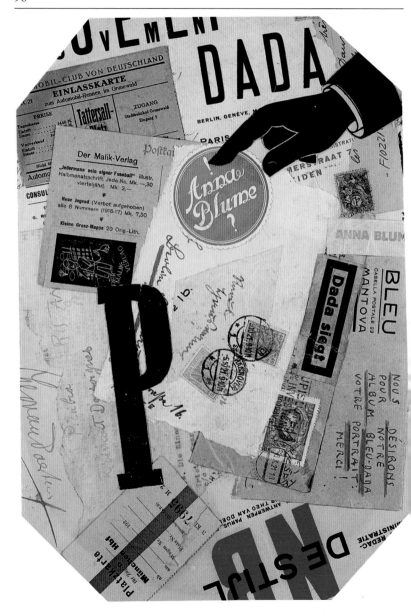

# DOCUMENTS

# Tristan Tzara: "1918 Dada Manifesto"

*Preceded by Tzara's early manifestoes, including "Mr. Antipyrine," the "1918 Dada Manifesto" touched off an explosion when on July 23, 1918 it was proclaimed by a twenty-two-year-old poet. Even today this twirling, sparkling, thundering text—which touched the central nerve, attacked logic, redefined art, denounced all ideas of community, and reinvented freedom of thought—has still not been widely read.*

One does not construct sensibility on a word; all construction converges on tedious perfection, the stagnant idea of a gilded swamp, a relative human product. The work of art should not be beauty in itself, because beauty is dead; neither cheerful nor sad, light nor dark, it should not delight or mistreat individualities by serving them the gâteaux of saintly haloes or the sweat from an arched race through the atmospheres. A work of art is never beautiful, by decree, objectively, for everyone. So criticism is futile, it exists only subjectively, for every individual, and without the slightest sense of generality. Do we believe we have found the physical basis that is common to all humanity? What the attempts by Jesus and the Bible cover under their broad, benevolent wings is: shit, beasts, days. How are we to bring order to the chaos of this infinite, formless variation: man? The principle of "love thy neighbor" is hypocritical. "Know thyself" is a Utopian idea, but a more acceptable one, which also contains spite. No pity. What remains to us after the carnage is a purified humanity. I always talk about myself because I do not want to convince, I do not have the right to drag others into my river, I do not force anyone to follow me, and everyone makes his art in his own way, if he knows the joy that shoots up to the astral layers, or that which goes down into the mines of corpses in bloom and fertile spasms. Stalactites: seek them everywhere, in cribs enlarged by sorrow, with eyes as white as the hairs of the angels.

Thus DADA was born of a need for independence, of mistrust of the community. Those who belong to us keep their freedom. We do not recognize any theory. We have had enough of the Cubist and Futurist academies and their experiments in formal ideas. Should art be created to earn money and flatter nice bourgeois people? The rhymes ring with the assonance of loose change, and the inflexion slides down along the line of the belly in profile. All groupings of artists have ended up at this money bank by straddling a variety of comets. The open door to possibilities of wallowing in cushions and food. Here we cast anchor, in the land of plenty. Here we

have the right to proclaim, because we have known shudders and awakening. Returning drunk with energy we plunge the triton into the carefree flesh.
We are cascades of curses in tropical abundance of giddy vegetations, rubber and rain is our sweat, we bleed and burn our thirst, our blood is vigor.

Cubism arose from the simple way of looking at an object; Cézanne painted a cup twenty centimeters lower than his eyes; the Cubists looked down on it directly from above, others complicate its appearance by making a perpendicular section and sensibly arranging it alongside. (I am not forgetting the creators, however, or the great reasons and the material which they claimed was definitive.)—The Futurist sees the same cup in motion, a succession of objects one next to the other, and mischievously adds a few force lines. That does not prevent the canvas from being a good or bad painting intended as an investment of intellectual capital. The new painter creates a world whose components are also the means, a sober, defined work, without argument. The new artist protests: he no longer paints/symbolic, illusionist reproduction/but creates directly using stone, wood, iron, pewter, rocks, organisms in motion which can be turned in all directions by the limpid wind of momentary sensation. Every pictorial or three-dimensional work is without purpose; let it be a monster that frightens servile minds, and not something sickly sweet to decorate the refectories of animals in human costumes, illustrations of this fable of humanity.

A painting is the art of making two lines meet that are seen to be geometrically parallel, on a canvas, in front of our eyes, in a reality which transposes onto a world with other conditions and possibilities. This world is not specified or defined in the work, it belongs in its innumerable variations to the spectator. For its creator, it is without cause or theory.

Order=disorder, me=non-me, affirmation=negation: supreme radiations of an absolute art. Absolute in purity of cosmic, ordered chaos, eternal in the second globule without duration without breath without light without control.—I love an old work for its novelty. It is only contrast that links us with the past.—What writers who teach us morality and discuss or improve the basis of psychology have, apart from a hidden desire to earn money, is a ridiculous knowledge of life, which they have classified, divided up, channeled; they are determined to see categories dancing when they beat time. Their readers giggle and read on; what is the point?

There is a literature that never gets through to the voracious masses. It is the work of creators, coming from a real need of the author's, and written for himself. The knowledge of a supreme egoism, where the laws wither away.—Every page must explode, either with deep, heavy seriousness, or with a whirlwind, a giddy feeling, with the new, the eternal, with crushing wit, with enthusiasm for principles, or with the way it is printed. On one side we see a tottering, fleeing world, betrothed to the tinkling bells of the infernal scale, on the other side we see: new men. Rough, leaping, riding on hiccups. We see a mutilated world where the literary quacks are badly in need of improvement.

—Tristan Tzara, extract from "Manifeste Dada 1918," in *Dada 3* (Zurich), December 1918

# A Free Art

*Raoul Hausmann, a major innovator of photomontage and the founder of Club Dada in Berlin, and Kurt Schwitters, the creator of the Merz rhizome in Hanover, produced a large corpus of political and theoretical work, somewhere between what the Spartacists in the street expected of them (an art that was committed to their cause) and what Cézanne called "the truth in painting." Art invented a new type of thought that overturned the power of images and developed a formal autonomy to accelerate a genuine poetic-revolutionary transformation. Schwitters wrote about the issues at stake in the "Proletarian Art Manifesto."*

## Raoul Hausmann, "Objective Reflections on the Role of Dadaism," 1920

When we speak of art, we cannot be unaware that the situation of the impartial artist in his "ivory tower" is only an image. Art has always taken sides—with power; in Europe, since the Greeks, this power has never belonged to the proletariat or even to "humanity," but to kings, dukes, lords, popes, bankers, and the Catholic bourgeoisie. We cannot forget that the artist went from the condition of slave or pariah in ancient times, to the status of an artisan in an organized guild in the Middle Ages and early Renaissance, and that his transformation into an individual of genius, enthroned in the clouds above the rest of humanity, is a recent invention. But even the genius created his work within the realm of "art," that is to say in the framework of a convention that was always dependent on the socio-economic, scientific, and technical infrastructure of his time—with this qualification, however, that it was exclusively at the service of the propertied classes on which it depended. For the genius's struggle against the bourgeoisie and capital was almost never a question of the "incomprehension" that later became fashionable; the issue was more one of the artist's lack of power as an individual to make this dependence on capital more lucrative for himself. This was a disadvantage resulting from the disappearance of the guilds, and the price that had to be paid for individual freedom. Today the great artist has perfected a technique that is guaranteed to lead to his recognition by capital; the "masses" do not interest him. What did the "sacredness" of art matter once the artist had handed his "beauty" over to the rogues, and the gold used for the frame was worth three

times more than the price of the work of art itself—then the artist, a true parasite on a parasite, felt himself hoisted for a few hours into the spheres of "real culture," a culture to whose creation he contributed, but in which he rarely took part directly, through lack of money or the right clothes to wear. Think about the situation that we call the breakthrough of an artist; it is nothing but the worst form of exploitation, a tremendous imposture that is masked by sacred words. After being left almost dying of hunger, this misunderstood genius is now, for commercial reasons, turned into a capitalist who, because he works a little more skillfully than thousands of others with his paper, canvas, or stone, emerges as a yardstick of quality and gains recognition. Nevertheless His Lordship the artist has done nothing more than understand that the "sacredness of art" and the "sacredness of creation" must be traded only for money, yes indeed, and that this money then becomes the only and the true meaning of art. Artists of this kind know that as a market value, they represent an element of the bourgeois power for whose preservation they tremble; even today they dare to claim that they are creating something human, a human transaction, which one is (perhaps) entitled to call "culture"— even though they know very well that among them the knives are out and they will stop at nothing to win the esteem of the bourgeoisie—in the form of a bank account!—and that they are absolutely and completely indifferent to the masses, to art, to humanity, and that they use all their prattle about art, nature, and the spirit solely to conceal their true motives and to adapt more easily to the wishes of the capitalist bourgeois, and that they

make him in his turn more docile with all their prattle about art for art's sake (enticing him with the idea that it is a great honor to be capable of understanding it). This lie, which the Dadaists have long since exposed, and whose mechanism they use to deceive the bourgeoisie, is widely used by their Lordships the artists of every school, academic, Impressionist, Expressionist, or whatever. But the most repugnant thing, which for the Dadaist runs counter to the most elementary self-knowledge, is that all this verbiage about "pure creation" is uttered aloud by those who are deceiving themselves the most shamelessly: Their Lordships the Expressionists. Most of the time they are just imitators of Kandinsky or Picasso who have taken the plunge ten years late into the "sea of the new form" and the "cathedral style"—people with no conviction other than now that their modernity has finally been won, it too is the most important thing in the world. These gentlemen talk endlessly about "pure art," "universal art," "construction"—without embodying anything other than an unconscious form of the perfect egotist. The result is that the "radical" artists of today know only two extreme positions: the ivory tower and universal love. They regard themselves as superior men, aesthetes, or like most artists, communists, and they feverishly develop programs that could be briefly summed up as follows: the "transformation of the world" will take place continuously, all that is needed is to regenerate this world with a large quantity of their products. But they are absolutely not Communists—they are merely insane philistines. Everything becomes clear when you think about the role of art

in society, and ask yourself whether or not it is possible for a radical or revolutionary art to exist, which the Dadaist denies, because he sees in art only a very limited scope for action, the will of man whose few short, little periods of turbulence, in between the long and perfectly conventional ones, will never be called revolutions by Dada. Even in the transposition of political tensions into painting or poetry, the Dadaist sees only an undesirable attenuation of political energy. In a situation of insurrection, he can only wish for the masses the ability to see things in an objective light—not one affected by "radical" poetizing or any other of their energies—the class struggle must finally be conducted without the need for lyricism. And for the Dadaist, the opportunity to emphasize the need for this struggle is offered only by satire and caricature, which seem to him the only non-compromised (artistic) forms. The only problem is that in Europe, art has always been a safety valve for the nostalgia that the European has for a life that does not exist. It is claimed that art is oriented toward an ideal, but in reality it has always served the purposes of the ruling classes, and contributed, not without condescension, to masking with the veils of beauty their conceptions of propriety and their methods of exploitation. The "free man," that "free and intelligible self," exists so rarely, and the freedom of art has existed so rarely that art has always been a conscious transformation of reality and has depended completely on general morality and the communal laws of society.

—"Objective Considerations on the Role of Dadaism," 1920

## Kurt Schwitters, "Proletarian Art Manifesto," 1923

*In 1918 Club Dada, or rather Huelsenbeck, rejected Schwitters on the pretext that he lacked political commitment. In 1923, however, he took a stand against what would become known as socialist realism. He published a manifesto, backed by the founding nucleus in Zurich and by Dutch Constructivism, in his own* Merz *review, which he had founded in January 1923 at the time of his Dada Merz tour in Holland with Doesburg, four months after the meeting between Dada and the Constructivists in Weimar.*

There is no art that relates to one particular class of men, and if there were, it would be of no importance to life.

To those who want to create a proletarian art, we ask the question: "What is proletarian art?" Is it an art created by the proletarians themselves? Or an art at the service of the proletariat alone? Or an art intended to arouse proletarian (revolutionary) instincts? There is no art created by proletarians because a proletarian who creates art is no longer a proletarian but an artist. An artist is neither proletarian nor bourgeois, and what he creates does not belong either to the proletariat or to the bourgeoisie, but to everyone. Art is a spiritual function of man, and aims to deliver him from the chaos of life (from the tragic). Art is free in the use of its means, and is ruled by its own laws and no laws other than its own; as soon as a work is a work of art, it rises far above the class differences between the proletariat and the bourgeoisie. If art were to serve the proletariat exclusively, despite the fact that the proletariat is contaminated by

bourgeois taste, this art would be as limited as an art specifically aimed at the bourgeoisie. Such an art would not be universal, and would not have its roots in universal national feeling, but in considerations that were individual, social, and limited in time and space. If art were to arouse instincts of a proletarian nature, it would simply use the same means as religious or nationalist art. Banal though it may seem, there is in fact no real difference between painting a Red Army led by Trotsky, or an imperial army led by Napoleon. The value of a painting as a work of art has nothing to do with arousing proletarian or patriotic sentiments. From the point of view of art, they are both fraudulent.

The only duty of art is to arouse by its own means the creative forces of mankind, its aim is the maturity of mankind, not of the proletariat or the bourgeoisie. Only lesser talents are driven, by lack of culture or narrowness of vision, to produce in a limited way something like proletarian art (politics in painting). The true artist turns his back on the specific field of social organizations.

The art that we want is neither proletarian nor bourgeois, because it needs to deploy a large amount of energy in order to influence the whole of a culture, rather than allowing itself to be influenced by social relations.

The proletariat is a condition in life that ought to be outdated, the bourgeoisie is a condition in life that ought to be outdated. But the proletarians who imitate the cult of the Bourgeoisie with their cult of the Proletariat are precisely those who are supporting this decaying bourgeois culture, without being aware that they are doing so: to the detriment of art and the detriment of culture.

With their conservative attachment to old forms of expression that have had their day, and with their absolutely incomprehensible disgust for the new art, they prolong the life of what, if their manifestoes are to be believed, they are supposed to be fighting against: bourgeois culture. And so ultimately we see bourgeois sentimentalism and bourgeois romanticism, despite the perseverance of radical artists in their efforts to put an end to them, living on and even being cultivated and supported again. Today Communism is already just as bourgeois a cause as democratic socialism, that is to say, the new capitalist formula. The bourgeoisie uses the apparatus of Communism—which is not an invention of the proletariat but of the bourgeoisie—with a view to renewing its decaying culture (Russia). In consequence, the proletarian artist is fighting neither for art nor for the new life to come, but for the bourgeoisie. A proletarian work of art is nothing but a poster advertising the bourgeoisie.

What we are working toward, on the other hand, is a total work of art that propels itself far above all the advertising posters, whether they sing the praises of champagne, Dada, or communist dictatorship.

—"Manifest Proletkunst," Theo van Doesburg, Hans Arp, C. Spengemann, Kurt Schwitters, Tristan Tzara, The Hague, March 6, 1923; published in "number i" of *Merz*, no. 2 (Hanover), April 1923

# Press Coverage: Dada/Spartacus versus Bourgeois Culture

*"I imagine that idiocy is the same everywhere," wrote Tzara to Picabia before arriving in Paris, "since everywhere there are journalists." But the press does provide a useful source of information about actions that have left no other trace, except, in this case, in the voices of hecklers, whom the press referred to as Spartacists, without identifying Dada. At this time Cologne was occupied by the British authorities; Max Ernst subsequently had difficulty obtaining a visa to go to Paris.*

**Spartacus Violates the Theater:**
**A Putsch That Did Not Succeed**
Yesterday an outrageous event caused great agitation in our Schauspielhaus. We have received this report of it:

"During a performance of *The Young King* by Raoul Konen, the auditorium of the very well-attended Schauspielhaus was the scene of a genuine putsch by the Spartacists. About thirty people attempted to interrupt the performance. The police called for reinforcements, and with the help of the gentlemen of the audience, finally made the Spartacists leave to the boos of the other spectators. About ten troublemakers had to be led away in handcuffs. The affair will have consequences. The actors are now filled with a hitherto unknown enthusiasm for the playwright and his work. The second act and the end of the five-act play were performed with all the lights on. At the end, the audience showed enthusiastic acclaim for Raoul Konen.

Another eyewitness gave us the following report: "Not long after the beginning of the performance, timid heckling could be heard from the auditorium. Then a man suddenly shouted out, 'But this is garbage!' and others exclaimed, 'This play is absolute trash.' A woman's voice shouted, 'Throw the author out, we can't watch a play like this!' Hundreds of voices demanded silence. People were whistling with their fingers and with keys. Some of the protestors ironically broke into the national anthem. The lights came on. The usherettes appeared, accompanied by burly men. Fighting broke out in various places. The demonstrators were dragged by force out of the auditorium and into the corridors, where they were given a beating. Policemen arrived immediately; several disrupters were taken away in chains. Then the show started again, and at the end of Act One, there was applause mixed with the shouts and whistles. The demonstrations started again in the second act, and more young men and women who had drawn attention to themselves by

their shouting and whistling had to be removed. It was not until the third act that everything calmed down."

It is extremely regrettable but in no way surprising, given the hatred that is manifesting itself in certain quarters, that the theater should become the scene of such demonstrations. It is also a sign of the times. Let us not forget that a small group with plenty of effrontery, nerve, and vulgarity wants to impose its will on the majority, and to introduce its Spartacism into art. It can only be a great honor for the work and its author that it should happen to be *The Young King* that has been subjected to such ugly, uncouth behavior. It is not Konen's drama that has been judged here, but a rabble with a far lower level of education and culture; these people do not deserve to have a great deal of fuss made about them, but nevertheless this event must be taken seriously in order to appreciate the extent to which the sense of good manners and tolerance has become debased in certain areas of society.

—"Spartakus vergewaltigt das Theater. Ein Putsch, der nicht geglückt ist," *Rheinischer Merkur* (Cologne), March 5, 1919

## Putsch in the Theater

On March 4, a demonstration was organized at our city's Schauspielhaus against the clerical, chivalrous piece of tripe by a certain Mr. Cohnen or Konen. Following the dictates of its bloated subconscious, the theater's management had shown a sense of humor by arranging the performance of its carnivalesque prince of pussycats for Shrove Tuesday (a day too early in any case).

Let us congratulate the author, a sort of ambitious Ash Wednesday herring from the same pond as the waxworks, Karl May, Lurley, and other fairground celebrities, for the hilarity he has caused.

Let us thank the theater's committee, management, and production department for their orgy of triply soporific innocence.

Finally, let us express our sincere "regrets" for the events, not regret for the methods used which, in calling on the republican conscience (no laughing please!), on the self-respect of a municipally insulted audience, on a consciousness wounded by these four murderous years, were evidence of a slightly embarrassing lack of knowledge on our part. Rather regret for "what happened," for all those splendid frock coat seams that were sacrificed to an audacious but doomed enterprise, regret for the interruption of the artistic and digestive sleep of the bourgeois, during which the personal cowardice of the awakened sleepers was able to have its brave little moment of sweating and dribbling under the protection of police officers, regret for the energy and calmness of the demonstrators in this situation. The theater, like every artistic embalmment of a dominant class, lives and dies with those whom it embalms, with the hegemony of the class in question. From this point of view, the artistic consumption of the bourgeois always has the same degree of maturity as its consumers. Its destiny cannot be decided either in front of or on the "boards," but in a place where another wind blows. It is there that it lives and dies.

—*Der Ventilator* (Cologne), no. 6, March 1919

# Early Memories

*Before writing his own memoirs under the title* Dada Art and Anti-art *in 1965, Hans Richter, a member of the first group in Zurich, provided a few early accounts, including "Dada XYZ" in 1948, in which he wrote about the Zurich period, and in particular about Hugo Ball. In the same year (which also saw the death of Antonin Artaud and the creationist Vicente Huidobro), Hannah Höch, who a friend of the inventor of Merz and Hausmann's partner at the time of Dada, learned that Schwitters had died from Christoph Spengemann, author of* The Truth about Anna Blume, a Critique of Art, a Critique of Criticism, a Critique of the Time *(1920).*

**Hans Richter, "Dada XYZ," 1948**

I never understood Hugo Ball very well. He was rather tall and very thin; when I first met him he looked to me like a dangerous criminal. I took his soft speech for a technique to put one off guard. His dark, mostly black clothes and black, wide brimmed hat, made him look abbé-like (another suspicious note).

When he recited his abstract poems in the enormously over-crowded DADA exhibition at the *Tiefenhoefe* in Zürich in 1917, towering over an exploding and applauding-laughing crowd of pretty girls and serious bourgeois, he was Savonarola, fanatical, unmoved, unsmiling.

He was human, nevertheless; he loved Emmy Hennings. When she could not make up her mind, whether a solid and handsome Spaniard or Ball was her favorite, he followed her with a revolver in his pocket (so she said) and searched my apartment, to learn whether the lovers were hidden there. Such problems concerned all of us, and Tzara and I had long conferences to make up the mind Emmy could not.

Of all the personalities in the Dada movement, Hugo Ball oscillated the most. By the end of 1917 he was deep in politics (in Berne, the capital), assisting the heroic Dr Hermann Roesemeier in the editing of a demo-cratic anti-Kaiser weekly (*Freie Zeitung*) which fought a hopeless battle against the past, present and future of All-German arrogance. He had become a hardworking, whisper-ing diplomat…not really. In a city that was full of spies, intrigues and "pulls," he was clearly one of the few idealists, whose intelligence was obviously great enough to attract

political figures.

The next time I heard from him, about 15 years later, he was buried near St. Abbondio in Southern Switzerland, where he had lived with his wife Emmy. I learned that Ball had become very religious. When he died in 1927 in St. Abbondio, people from all over the Ticino (the southern, Italian-speaking canton of Switzerland) had come to his funeral, as they had come to him for help and advice during his life among them. Emmy Hennings, a protestant, always had a strong leaning towards the mysticism of the church, but Ball had made faith, the Catholic faith, finally the theme of his life. He had visited Rome, and the priests of the church respected him as one of their own. When I left Switzerland in 1941, fourteen years after his death, the people of the canton still spoke with admiration and love of his sincerity and goodness. He had become a kind of saint. My first judgement had been very wrong, he was a good man.

—Published in Robert Motherwell, *Dada Painters and Poets*, New York, 1951

## Hannah Höch, Letter to Christoph Spengemann, February 17, 1948

*Unlike her Dada friends, Hannah Höch did not flee from Germany during the war, but hid and continued to live an untroubled life in Heiligensee—a secluded part of Berlin, almost in the Eastern zone beyond West Berlin—in a home that had previously belonged to the warden of an airfield that was no longer used.*

Very many thanks for your letter. When I saw the name of the sender, I was delighted to hear from you, but then—it contained a dreadful piece of news. I am so sad that our dear Kurt Schwitters is also no longer with us. We went through so much together, and I was hoping to have a reunion with Kurt. He had written to say that he wanted to visit us in Germany. And he also hoped that the *Merzbau* would be unearthed. And as well as that, he suffered so much—our poor and very dear friend. I feel with you how much you must have been affected by his death, my dear Christoph Spengemann, because you spent even more time than I did with this unique and very strong person- ality, and he always spoke of you as the one person who fully understood him. I myself had a friendship and a spiritual companionship with him of a sort that must be very rarely possible between the two sexes. We were united by many unforgettable hours spent together. When he was in Berlin, we were never apart. I followed him everywhere—because there was not a single uninteresting minute with him. And then there were the many journeys that we made together, with Helma, of course. Many times I came, as you know, to Hanover, then to Holland, Prague, and Dresden, and one summer to Göhren on the island of Rügen. His activity, his spirituality, his love of animals and people, his universal independence in spite of all the bourgeois restrictions made him an exceptional man. And then—for twelve years we were not able to see each other, until this shameful period of twelve years had passed—and now death is creating one gap after another.

—in Hannah Höch, *Collages*, Institute für Auslandsbeziehungen, Stuttgart, VG Bild-Kunst, 1984

# Franz Jung: *The Downhill Path*

*Franz Jung helped and even launched Dada in Berlin. The Dadaists published their first articles and engravings in his review, the* Freie Strasse. *Issue 8 marked the beginning of Club Dada. Issues 9 and 10 were designed by Hausmann. This extract from* Der Weg nach Unten (The Downhill Path) *was written in the United States, where he had gone to live in 1948, and it is his only account of Dada, telling of a brief episode in his very full life as an activist. Franz Jung is also known for having hijacked a boat in mid-voyage to get to Russia. He minimized the role of Huelsenbeck, gave prominence to Hausmann, and confirmed the truth of the legend according to which Baader had been prepared for action by his friend, the Dadasopher Raoul Hausmann.*

What appeared to be a movement in Berlin had nothing in common with the "Dada" movement that was concentrated in Zurich around the Cabaret Voltaire, apart from the name, which did, it must be said, prove very useful for our provocations. Whereas the Dadaism of Arp and Tristan Tzara represented some aesthetic advances, nothing like that happened in Berlin at the beginning. Richard Huelsenbeck, who had re-emigrated from the Cabaret Voltaire circle to Berlin, was welcomed as a witness of what the groups of artists who had emigrated to Switzerland, and even elsewhere, had started to do to rid themselves of the yoke of aesthetic traditions, under which Futurism had failed. Huelsenbeck was a promising writer in his early publications, but he did not have the slightest influence on us. He always remained an outsider. He was tolerated to some extent as an enthusiast, and as an alibi for the name Dada, but nothing more....

In my opinion, Raoul Hausmann was the most gifted of these intellectual agitators, an excellent painter and inveterate abstract philosopher, who was equally serious about creating a new fashion for men as he was about astronomy and mathematics. In between times he also invented a Superdada in the person of the architect Baader.

I do not know whether Baader really was an architect, or whether he had sold land that did not belong to him, which had supposedly forced him to flee to the army in order to avoid the resulting difficulties. What has been proved by witnesses is that he had

called Kaiser Wilhelm from the front in Brussels, and passed on to him an order from God that he should immediately make peace. That same day he was sent back to Germany and probably interned. He had a wife and four children, whom none of us ever saw.

One day Hausmann, whose studio was in the Steglitz neighborhood, came upon him in a deserted hilly area; Baader the prophet was surrounded by several elderly men and women, to whom he was delivering a sermon on the army of He who, when the time came, was going to destroy all other armies, with him, Baader, as a simple adjutant.

Hausmann took him to his studio, and molded him into Superdada; just what ways and means he used to do this, I do not know.

Hausmann would push him along in front of him like a poor idiot being used as a punchball. Baader was normally an inoffensive, amiable man, somewhat stupid and looking remarkably similar to the cigar-seller on the street corner. Baader moved and spoke as Hausmann told him to.

Baader produced his masterpiece when, surrounded by Hausmann and other instructors in the tram to Steglitz, he noticed the Reichstag representative Philipp Scheidemann. Scheidemann was wedged onto the rear platform of the train by Baader and his followers. Baader, who had grown a pastoral beard, made a speech in a thundering voice that could be heard all along the street, and named Philipp Scheidemann as Dada of Honor. Scheidemann did not know how to take it, then in the end the "people" started talking to him. He was very embarrassed, and it was quite a while before he managed to escape. A few weeks later, Scheidemann was proclaimed Chancellor of the Republic;

the link between Dada and the Revolution was made....

The true center of our spirit of play and provocation was the *Neue Jugend* review. It was in broadsheet format, similar to the London *Times*, which was a considerable feat at a time when measures were being taken to ration paper and ban new publications. Sometimes printed in four colors, sometimes in white letters on black paper, it was a real pleasure to look at. We launched an appeal, via an office with a fictitious address, to collect food ration cards for prisoners of war; a starving Germany would not forget the distress of its enemies. George Grosz fulminated on the importance of cycling; with no bicycles there would be no politics.

But the moving spirit of it all was Jonny Heartfield. It is impossible to imagine, except in one's memory, everything that Jonny achieved. We could only put the manuscript together piece by piece, and we had to have it printed by various different printers. Of course we had no license or publishing address. We were deceiving the printer and the police. Despite everything, Jonny managed to supply copies to some large news agents. People only bought the paper for its presentation; but there was nothing in it about the peace, and that was the one thing that the police were interested in hunting down. The copies had to be sold within one hour. On the whole, only a small number of copies were seized each time. We distributed most of them on the quiet, or sent them by post, protected by navigation service envelopes.

—Franz Jung, from *Der Weg nach Unten*, 1962

# Anthology of Dada Poetry

*Although generally seen from the point of view of painting, most avant-garde movements were thought out, theorized, and launched by poets, who saw poetry as capable of starting a profound revolution and achieving a conceptual leap. By reinventing words and the whole of language—that of painting, manifestoes, and theoretical statements—they could poeticize the dull political hum of the press, and politicize the poetic genre: "the sudden leap of vowels."*

**Hugo Ball, "gadji beri bimba"**
gadji beri bimba glandridi laula lonni
cadori
gadjama gramma berida bimbala
glandri
galassassa laulitalomini
gadji beri bin blassa glassala laula
lonni
cadorsu sassala bim
gadjama tuffm i zinzalla binban gligla
wowolimai bin beri ban
o katalominai rhinozerossola
hopsamen
laulitalomini hoooo
gadjama rhinozerossola hopsamen
bluku terullala blaulala loooo

zimzim urullala zimzim urullala
zimzim
zanzibar zimzalla zam
elifantolim brussala bulomen brussala
bulomen tromtata
velo da bang bang affalo purzamai
affalo
purzamai lengado tor
gadjama bimbalo glandridi glassala
zingtata pimpala ögrögöööö
viola laxato viola zimbrabim viola uli

paluji malooo

tuffm in zimbrabim negramai
bumbalo
negramai bumbalo tuffm i zim
gadjama bimbala oo beri gadjama gaga
di gadjama affalo pinx
gaga di bumbalo bumbalo gadajamen
gaga di bling blong
gaga blung
      —Read on June 23, 1916 at the
Cabaret Voltaire, from Hugo Ball,
*Gesammelte Gedichte*
(Zurich: Der Arche, 1963)

**Tristan Tzara, "Calendar"**
bottle with wings of red wax in bloom
my calendar leaps medicinally
astral of futile improvement
dissolves by the lit candle of
my principal nerve
I love office accessories
for example
fishing for little gods
gift of color and farce
for the odorous chapter where nothing
matters at all
on the track comfort of the soul

and the muscle
bird screeches

with your clenched fingers stretching
out and
staggering like eyes
the flame calls to clasp
are you there under the blanket
the stores spit out the employees
midday
the wheel carries them off
the bells of the trams cut the
strong sentence

wind desire sonorous vault of
insomnia
tempest temple
the waters cascading
and the sudden leap of vowels
in eyes that stare at the points
of abysses
to come to surpass lived to conceive
call the light human bodies
like matches
in all the fires of autumn
vibrations and trees
sweat of petroleum
　　　　—*Dada 3* (Zurich), December 1918

**Louis Aragon, "For Tomorrow"**
You whom the spring brought about
Miracles punctuate my stance
My spirit in love with departure
in a sudden ray is lost
perpetuated by the cadence

The Seine in the April sun dances
like Cécile at her first ball
or rather rolls nuggets
toward the stone bridges or the
screens
Sure charm The city is the valley

The quays as gay as at carnival time
go ahead of the light
It　　　visits the palaces

that appear according to its games or
laws
Me, I honor it in my way

The only day of truancy
and not Silenus taught me it
this drunkenness color of lips
and the roses of the day at the
windows
Like girls at the Opera
　　　　—*Littérature* no. 4 (June 1919)

**Louis Aragon: "Suicide"**
A b c d e f
g h i j k l
m n o p q r
s t u v w
x y z
　　　—*Cannibale* no. 1 (April 25, 1920)

**Francis Picabia**
Happiness for me is not to
command anyone and not to
be commanded.

Look in the distance, do not look
back, we talk unreason when we want
always to know the reasons.

Envy seems to me to be the greatest
obstacle to happiness for the French.
　　　　—*391* (New York) no. 6, July 1917

**Jean Arp, "Manifesto of the Dada
Crocrodarium"**
The lamps statues come out of the
bottom of
the sea and cry long live DADA to
salute
the transatlantic liners that pass and
the
presidents dada le dada la dada les
dadas une dada un dada and three
rabbits
in india ink by dadaist arp
in streaked bicycle porcelain we

will go to London in the royal
aquarium ask in all the
pharmacies for the dadaists of rasputin
of the tzar and the pope who are only
valid
for two and a half hours.

—"Vingt-trois manifestes du
Mouvement Dada,"
*Littérature* no. 13 (May 1920)

**Arp, Serner, Tzara, Society for
the Exploitation of the Dadaist
Vocabulary**

**Richard Huelsenbeck,
"Metamorphoses"**
Cacadoo in color the stained-glass
ears run around the yellow star of
Klumbumboo. Good. Cacadoo
becomes butter Jamaica cognac steel
becomes dance path of butter is
corkscrew for infantile oteros in bags
Chinese spit for years on end for
petroleum. One of Confidence fattens
to red a semicolon. Apoplexy. Dragon
salad, telegraphic, yet how. Toreador
of the green tie before the eyes stuffed
cakes at the end of neuralgic threads
phart phart says the poet the tribune
of the heart and Geneva par excellence
Easter. Not easy to give clear conscience
to rapidities. All in all vehement
pages. To be bought. H.A. W.S. T.T.
—*Dada 4–5* (Zurich), May 1919
(Munich: Roland),

**Kurt Schwitters, "The Prisoner"**
Shooting prohibited here bitter sauce
culminates itself. The violet has a
black butter eye, with which the green
fish sob around a corpse of fried
yellow seagulls. (German everyday
life). For my wife has a very salty
tongue behind the head wriggles the
curdled milk tail. Raoul Hausmann
gently crumbles tender erect ardors

accumulate whirlwind on the left (by
the right). Blood bubbles in the
grooved veins in front of Apollinaire
around peaks mountains stand firm to
right and left. To right and left. To left
and right. One, two, one two, one two,
one the sound beam in the eye to
search. Your eye, Anna Blume, your
eye remains without a tear. You tame
to warble Apyl silk stocking can
signify madame, by Gauguin not by
cloud pump. Jean arp to be in error
Anna Blume green fir pump left. One!
One! Left right, left right. One. Left.
Left. Two. One. Left two one. Two
one. One. Eight.

**Kurt Schwitters, "WALL"**
Five Four Three Two One
Wall
Wall
WALL
WALL WALL WALL
WALL WALL WALL
WALL   WALL   WALL   WALL
walls
walls
Walls
WALLS WALLS WALLS
WALLS  WALLS  WALLS  WALLS
WALL
WALL WALL WALL
WALL WALL WALL
wall wall wall
wall
wall
wall

wall
—Kurt Schwitters, *Anna Blume*
(1919 and 1922)

**Raoul Hausmann, "Year 1 of World
Peace"**
Dada notice
Hirsch copper stocks are down. Will

Germany die of starvation? Then it must sign. Young lady sporty elegant type, size forty-two for Hermann Loeb. If Germany does not sign, it probably will sign. On the money market the value of currencies is falling. If Germany signs all the same, it will probably sign in order not to sign. Amor rooms. Eveningnewsat-eighto'clockwithbruissementceleste. By Viktorhahn. Lloyd George considers that it is possible that Clémenceau is of the opinion that Wilson thinks that Germany should sign because it cannot not sign. In consequence Club Dada declares itself in favor of total freedom of the press, the press is a medium of culture without which no one would know that in the end Germany will not sign, just in order to sign. Club Dada, Section for the freedom of the press, within the limits tolerated by common decency.

—*Der Dada*, no. 1 (June 1919)

**Maz Ernst, "The Old Rebels' Song"**
The reed pipes the tumtetums
the whooping coughs the whoops the
traveling performers of old sheep wax
the lips of night revellers
They play with tubs and
magic sticks
They swallow the rickshaw
the pumpadon the serial
To start with there is chicken with
donkey
and to finish there are the eggs
of the correligionaries
We are all lighter
than Europium because we
are slightly Americanized
We wear porpoise boots
We have no chemical cohesion

—*Création* no. 2 (Paris, 1921)

**Francis Picabia, "Anecdote"**
You see, I am crazy to imagine it
I am a man with nimble fingers
Who wants to cut the threads of old
pains
False folds in my anxious brain
History in arabesques memories
I am only happy on the open sea
Where one goes further
On anonymous waves.

—*Poèmes et dessins de la Fille née sans mère* (Lausanne: Imprimeries réunies, 1918)

**Georges Ribemont-Dessaignes, "Garden"**
The blue eye of the stars that sways
on the point of a needle
Sweeps the tears from the parquet of
the heart
And all the little sweat-sucking angels
Have made their nests in a top
hat
Then the flower spreads its legs.

—*Man Ray*, Librairie Six, December 1921

**Marcel Duchamp**
Rrose Sélavy finds that an incesticide must sleep with his mother before killing her; thumbtacks are de rigueur.

—*Littérature* no. 5 (October 1922)

Rrose Sélavy and I elude
the ecchymoses of the Eskimos
with exquisite words.

—*391* no. 18 (July 1924)

# Paris, 1920: Dada Moves to France

*In 1923 the fashion designer and patron of the arts Jacques Doucet, who was setting up one of the best literary libraries in Paris on the place du Panthéon, asked some young authors to chronicle their lives and reflections. With varying degrees of success a number of writers took up the tempting offer. Aragon used this as an opportunity to produce a remarkable piece of writing that, oddly, was not published until 1994. This account is followed here by a short autobiographical piece by the modest Clément Pansaers, whose poetic work Aragon admired and spoke of from time to time throughout his life, always with great warmth.*

### Louis Aragon, "Tristan Tzara arrives in Paris," 1923

As we were entering the drawing-room at rue Emile-Augier, where the higgledy-piggledy mechanical paintings and eighteenth-century furniture seemed expectant, the door of the adjoining bedroom opened, and in came a small dark-haired man who took three hurried steps then stopped, at which point we realized that he was near-sighted. It was Tzara whom I was coming to see, but never having imagined him looking like this, a young Japanese with a pince-nez, I hesitated for a moment, and so did he. So this was the agitator whom we had summoned to Paris, the one who in his photograph in leather gloves looked like Jacques Vaché, and whose poetry was currently being compared to Rimbaud's (and that was saying a lot). With his elbows pressed to his body, and his very fine hands half open at the end of his horizontal forearms, he looked a little like a night bird frightened by the daylight, with his black forelock falling into his eyes. The first impression of him was that he was very good-looking, but after two minutes of conversation a laugh burst forth and shook out a plume of three hairs at the end of his part that split his face and disfigured it. How ugly he was! The laugh gave way to a sort of astonished look which restored the oriental finesse to a face as pale as that of a dead man, all of whose fire has withdrawn into his very beautiful black eyes. At that time, I mean when he arrived in Paris, he spoke slowly and quite inaccurately, with a very pronounced Rumanian accent; I remember that he said Dada with two very short a's, and that it was Théodore Fraenkel who taught him to say it as we do here.

—Aragon, *Projet d'histoire littéraire contemporaine* [1923], Mercure de France / Gallimard, "Digraphe," 1994

## Clément Pansaers: "Fantasy Riding on the Back of Chance," 1920

*Less well-known than others but more authentically Dada, as the Antwerp poet Paul Neuhuys described him, Pansaers was also a political activist. He took part in the Spartacist soldier-workers' uprising in Brussels, along with the writer and critic Carl Einstein, who publicly degraded his superiors and gave them his orders. He had an exceptional mind, and was the author of dazzling works such as* Le Pan-Pan au cul du Nu nègre *and* Bar Nicanor, *and a close follower of Tao and Tchouang Tseu. He arrived in Paris in April 1921. During an incident at the Café Certá, he clashed with Breton, whom he described in* 391 *as a "Platonic teacher swollen to the violet-purple of excommunication." It was in Berlin, when he was with Einstein, that he had become a member of Dada by writing to Tristan Tzara at the end of 1919. Disappointed with the group, and not much enthused by the Max Ernst exhibit, he became friendly with Joyce, Pound, and Brancusi, and made plans with them for a new review,* Bilboquet, *"to enlarge the significance of Dada or whatever it will be called." He died prematurely in 1922, however, unknown to anyone except a few recent friends. In the fall of 1921, he had put together an issue called "Dada, Its Birth, Its Life, and Its Death" for the magazine* Ça ira!

It was in 1916, after three months of meditation on a blind white wall— that I grasped the true meaning of life—I repeat that I was thus born in 1916—I was living at that time in La Hulpe near Brussels on the edge of the Forêt de Soignes very close to the former home of the Flemish mystic Ruysbroeck—

The "young" of Brussels—painters, poets—on their weekly pilgrimage to the beauties of nature came and rested in my very sentimental "House at the Forest's Edge"—They were sub-Cézannes—sub-van Goghs—and the most advanced were pseudo-Cubist lovers of nature and Walt Whitmanians who wrote about human goodness—

I had done some sculpture—which was not Bourdelle or Maillol, and they thought it was Archipenko-style fantasy—then I understood—after six months of meditation on a blind white wall—that nothing in life is interesting except fantasy riding on the back of chance—the most enthusiastic ones granted me a minimum of confidence— I started editing a review called *Resurrection* and our little group held meetings in Brussels at the "Diable au Corps"—

There I demonstrated that fantasy radically destroys logic inherited from the old philosophers and replaced by psychology, and that the result is the destruction of all the literature of Anatole France, Bourget, etc., the words in waffle have lost all meaning—since they have multiple meanings—syntax is written by grammarians according to what authors write, so nothing fixed and my syntax does not correspond to that of others—I demonstrated all that by facts—poems—

—Clément Pansaers,
*Sur un aveugle mur blanc*, 1972.
*Bar Nicanor*, Champ Libre/
Gérard Lebovici, 1986

# Dada Is a Protest

*Shortly before his arrival in Paris in 1920, Tzara sent a "right of reply" to the* Nouvelle Revue Française, *which had ironized the "twaddle" of the Dada movement, lumping together Baader in Berlin and Tzara in Zurich. It was Breton, however, who published Tzara's reply in* Littérature *in 1919. It became one of Tzara's emblematic texts, and gave the review the idea of launching the "Why Do You Write?" survey. Three years later, the writer Roger Vitrac interviewed Tzara at the time when Dada was in decline.*

**Tristan Tzara, extract from "Open Letter to Jacques Rivière"**

Today writing is no longer a matter of race, but of blood (what a platitude!). What for the other literature was the *characteristic* is now the *temperament*. It does not much matter whether one writes a poem in Siamese or whether one dances on a locomotive. It is only natural for old men not to notice that a new type of man is coming into being all over the place. With insignificant variations according to race, the intensity is, I think, the same everywhere, and if there is a common character to be found in those who are creating the literature of today, it will be that of anti-psychology.

If one writes, it is only a refuge: from every "point of view." I do not write as a profession, and I have no literary ambitions. I would have become a dashing, noble adventurer if I had had the physical strength and the nervous resistance to achieve this one feat: not to be bored. People also write because there are not enough new men, by force of habit one publishes to find men, and to have an occupation (that itself is very stupid). There would be a solution: to resign oneself; quite simply: to do nothing. But that takes enormous energy. And people have an almost hygienic need for complications.

—*Littérature* no. 10 (December 1919)

**"Tristan Tzara Is Going to Cultivate His Vices," interview with Roger Vitrac**

I must say, however, that when I started writing, it was more for action against literature and art. If I am still writing now, which is very rarely in fact, it is through weakness, and above all because, being tired of poetry in external life, I am looking for it inside myself. I should add that I write only for myself.

—You wrote, did you not, in the letter that you have mentioned: "I try not to waste any opportunity to compromise myself." Would you still do that?

—Certainly. In fact, that is all I do. And if I do not do it publicly, it is

because I have no public life.

—What is the attitude that would seem most appealing to you today?

—Ah! It isn't to do with destroying literature! I would prefer instead for the individual to destroy himself. I also find that there is a very subtle way, even while writing, of destroying the liking for literature. This is to combat it by its own means and in its formulae. But literature does not much interest me. What interests me is poetry and not, as one might be tempted to think, my poetry.

If I do not make a commitment not to write any more, it is first of all because I am not sure of myself, and also because any method that is pushed to its extreme conclusions seems to me to be a restriction of the individual, and one which is no different from the formula of literature itself.

What would appeal to me would be to lose my personality, to abandon every type of pretension, in a word to become apersonal.

—Would you like to give me a definition of poetry as you conceive of it?

—Poetry is a means of communicating a certain amount of humanity, of elements of life, that one has within oneself.

—Do you not think that many of your ideas are compromised by the current literary madness?

—I don't know what you mean by that. I read nothing. But you can say that I am not against publicity, or against success, because I regard them as elements of life which are as acceptable as their opposites.

—Are you an arriviste?

—Obviously. Very much so. What I like most in life is money and women. But I have very little money and am very unlucky in love. Incidentally, I do not believe that any perfection exists, and I think that impurities and diseases are as useful as the microbes in water are necessary to the digestion.

—Why are you an arriviste?

—I am one because I want to cultivate my vices: love, money, poetry. I will push them to their ultimate limits. And I am very afraid that I will not achieve my end before I die. I hasten to add, however, that my arrivisme is without pretension.

—Did you think of Dadaism as an end?

—Never. And what is more, I am anxious to not mention that word any more. Dada was a purely personal adventure, the materialization of my disgust. Perhaps it had results, consequences. Before it, all modern writers kept to a discipline, a rule, a unity. Apollinaire's aesthetic was limited by the picturesque. Reverdy's poems seemed to have been worked out in advance. After Dada, active indifference, the current "I couldn't care less" attitude, spontaneity, and relativity came into life....

—What do you think of modernism?

—If what you mean is that intellectual upsurge that has always existed, and which Apollinaire called the new Spirit, modernism does not interest me at all. And I think that people have been wrong to say that Dadaism, Cubism, and Futurism all shared a common background. The latter two tendencies were primarily based on a principle of technical or intellectual perfection, whereas Dadaism never rested on any theory, and was nothing but a protest.

—*Journal du Peuple*, April 14, 1923

## SELECTED BIBLIOGRAPHY

### Louis Aragon (1897–1982)

Aragon, Louis. *The Adventures of Telemachus (Les Aventures de Télémaque)*. Trans. Renée Riese Hubert and Judd D. Hubert. Lincoln: University of Nebraska Press, 1988.

*Anicet ou le Panorama. Roman*. Paris: Gallimard, 1921.

*Les Collages*. Paris: Hermann, 1965.

*Chroniques*. I, 1918–1932. Ed. Bernard Leuilliot. Stock, 1998.

*Irene's Cunt*. Creation Pub Group, 1996.

*Lautréamont et nous*. Toulouse: Sables, 1992.

*Papiers inédits: De Dada au surréalisme (1917–1931)*. Ed. Lionel Follet and Edouard Ruiz. Paris: Gallimard, 2000.

*Paris Peasant*. Trans. Simon Watson Taylor. Boston: Exact Change, 1995.

*Projet d'histoire littéraire contemporaine (1923)*. Ed. Marc Dachy. Paris: Gallimard/Mercure de France, 1994.

*Une vague de rêves*. Paris: Seghers, 1990.

### Jean Arp (1886–1966)

*Arp: Line and Form*. New York: Mitchell-Innes and Nash, 2000.

*Arp: Reliefs*. Henry Moore Sculpture Trust, 1995.

Cathelin, Jean. *Jean Arp*. New York: Grove Press, 1960.

*Jours effeuillés (1920–1965)*. Ed. Marcel Jean. Paris: Gallimard, 1966.

*Sculpture by Jean Arp*. New York: Sidney Janis Gallery, 1968.

### Johannes Baader (1876–1955)

*Johannes Baader, Oberdada*. Lahn-Giessen: Anabas, 1977.

### Hugo Ball (1886–1927)

*Ball and Hammer: Hugo Ball's Tenderenda the Fantast (Tenderenda le fantasque)*. Trans. Jeffrey T. Schnapp and Jonathan Hammer. New Haven: Yale University Press, 2002.

*Blago Bung, Blago Bung, Bosso Fataka! First Texts of German Dada by Hugo Ball, Richard Huelsenbeck, Walter Serner*. Trans. Malcolm Green. London: Atlas Press, 1995

*Flight out of Time: A Dada Diary*. Ed. John Elderfield. Trans. Ann Raines. Berkeley and Los Angeles: University of California Press, 1996.

### André Breton (1896–1966)

*Mad Love*. Trans. Mary Ann Caws. Lincoln: University of Nebraska Press, 1988.

*Manifestoes of Surrealism*. Trans. Richard Seaver and Helen R. Lane. Ann Arbor: University of Michigan Press, 1969.

*Nadja*. Trans. Richard Howard. Grove Press, 1960.

*Oeuvres complètes*. I. Ed. Marguerite Bonnet. Paris: Gallimard, 1988.

*Selections by André Breton*. Ed. and Trans. Mark Polizzotti. Los Angeles: University of California Press, 2003.

*Surrealism and Painting*, Trans. Simon Watson Taylor. Boston: Museum of Fine Arts, 2002.

### Gabrielle Buffet-Picabia (1881–1985)

*Aires abstraites*. Preface by Jean Arp. Geneva. Cailler, 1957. New enl. ed., Paris: Belfond, 1977.

### Arthur Cravan (1887–1918)

*Oeuvres, poèmes, articles, lettres*. Ed. Jean-Pierre Begot. Paris: Champ Libre, 1987.

### Theo van Doesburg (1883–1931)

*Qu'est-ce que Dada? Lettres à Tristan Tzara*. Ed. Marc Dachy. Paris: L'Échoppe, 1992, 2005.

### Marcel Duchamp (1887–1968)

*Affectionately. Marcel. The Selected Correspondence of Marcel Duchamp*. Ed. Francis M. Naumann. Amsterdam: Ludion, 2000.

Cabanne, Pierre. *Dialogues with Marcel Duchamp*. London: Thames and Hudson, 1971. Reprint, New York: Museum of Modern Art, Cambridge, Mass.: Da Capo Press, 1987.

Camfield, William. *Fountain*. Houston: Houston Fine Art Press, 1989.

*Marcel Duchamp*. Exh. cat. New York: Museum of Modern Art and Philadelphia: Philadelphia Museum of Art, 1973, 1989.

Mascheck, Joseph. *Marcel Duchamp in Perspective*. Cambridge, Mass.: Da Capo Press, 2002.

Schwarz. Arturo. *The Complete Works of Marcel Duchamp*. New York: Harry N. Abrams, 1969. New enl. ed. Delano Greenidge, 2001.

Tomkins, Calvin. *Duchamp: A Biography*. New York: Owl Books, 1998.

*The Writings of Marcel Duchamp*. Ed.
Michael Sanouillet and Elmer Peterson.
Cambridge, Mass.: Da Capo Press, 1989.

**Viking Eggeling (1880–1925)**
Louise O'Konor. *Viking Eggeling, Life and
Work*. Stockholm: Studies in History of Art.
23. Stockholm: Almqvist & Wiksell, 1971.

**Paul Eluard (1895–1952)**
*Selected Poems by Paul Eluard* (bilingual
edition). Trans. Gilbert Bowen. Calder
Publications. Reprint 1988.

**Max Ernst (1891–1976)**
Bischoff, Ulrich. *Max Ernst*. Trans. Judith
Harrison. Cologne: Taschen, 2003.
Camfield. William A. *Max Ernst, Dada, and
the Dawn of Surrealism*. New York:
Museum of Modern Art; Houston: The
Menil Collection, 1993.
Russell, John. *Max Ernst: Life and Work*.
New York: Harry N. Abrams, 1967.

**Otto Flake (1880–1963)**
*Nein und Ja*. Frankfurt: Fischer, 1920.
Reprint, Munich: Klaus Renner, 1982.

**George Grosz (1893–1959)**
Anders, Günther. *George Grosz*. Paris: Allia.
2005.
*George Grosz: An Autobiography*. Trans.
Nora Hodges. Los Angeles: University of
California Press, 1998.

**Raoul Hausmann (1886–1971)**
Benson, Timothy. *Raoul Hausmann and
Berlin Dada*. Ann Arbor, Michigan: UMI
Research Press, 1987.
*Courrier Dada*. Paris: Allia, 1992, 2004.
*Kaléidoscope*. Ed. Adelheid Koch-Didier.
*Cahiers Raoul Hausmann*. no. 2. Musée de
Rochechouart, 1997.
*La Poésie a pour objet le MOT*. Ed. Adelheid
Koch-Didier. *Cahiers Raoul Hausmann*
no. 1. Musée de Rochechouart, 1997.
*Zürich-Dadaco-Dadaglobe: The
Correspondence between Raoul Hausmann,
Tristan Tzara, and Kurt Wolff (1916–1924)*.
Trans. Richard Sheppard. Hutton Press, 1982.

**Hannah Höch (1889–1978)**
*Album*. Ed. Gunda Luyken. Ostfildern-Ruit:
Hatze Cantz, 2004.
*Hannah Höch*. Museo Nacional Centro de

Arte Reina Sofia, Madrid/Aldeasa, 2004.
Lavin, Maud. *Cut with the Kitchen Knife:
The Weimar Photomontages of Hannah
Höch*. New Haven: Yale University Press,
1993.
*The Photomontages of Hannah Höch*.
Minneapolis: Walker Art Center, 1996.

**Richard Huelsenbeck (1892–1974)**
*The Dada Almanac*. London: Atlas Press,
1994.
Huelsenbeck, Richard, et al. *Memoirs of a
Dada Drummer*. New York: Viking, 1974.

**Vicente Huidobro (1883–1948)**
*Altazor*. Trans. Eliot Weinberger.
Middletown, Conn.: Wesleyan University
Press, 2003.

**Marcel Janco (1895–1984)**
Mendelson, Marcel L. *Marcel Janco*. Tel
Aviv: Massadah, 1962.

**Man Ray (1890–1976)**
*Self-portrait*. Reprint Boston: Bulfinch, 1999.
Foresta, Merry, et al. *Man Ray*. Paris:
Gallimard, 1989.
*Man Ray*. Paris: Le Seuil and Centre Georges
Pompidou, 1998.
*Man Ray: Paris Photographs, 1920–1934*.
Delano Greenidge, 2001.

**Clément Pansaers (1885–1922)**
*Bar Nicanor & autres textes Dada*. Ed. Marc
Dachy. Lebovici/Paris: Champ Libre, 1985.
*Pan-Pan au Cul du Nègre and Bar Nicanor*.
Facsimile reprint. Brussels: Devillez, 2002.

**Benjamin Péret (1899–1959)**
*Death and the Pigs: Selected Writings of
Benjamin Péret*. Ed. Rachel Stella. Boston:
Exact Change, 2001.
*From the Hidden Storehouse: Selected
Poems of Benjamin Péret*. Trans. Kenneth
Hollamann. Oberlin, Ohio: Oberlin
College Press, 1981.

**Francis Picabia (1879–1953)**
Camfield, William. *Francis Picabia, His Art,
Life and Times*. Princeton: Princeton
University Press, 1979.
*Écrits. I (1913–1920) et II (1921–1953)*. Ed.
Olivier Revault d'Allonnes. Belfond, 1975,
1978.
*Francis Picabia, singulier idéal*. Paris: Musée

d'Art moderne de la Ville de Paris, 2002.
*Yes no : Poems and Sayings.* Trans. Remy
Hall. Hanuman Books, 1990.

**Georges Ribemont-Dessaignes (1884–1974)**
*Déjà jadis ou du Mouvement Dada à
l'espace abstrait.* Paris: Julliard, 1958.
*Dada, 1915–1929.* Ed. Jean-Pierre Begot.
Paris: Champ Libre, 1974; Ivrea, 1994.

**Hans Richter (1888–1976)**
*Dada. Art and Anti-art.* Reprint. London:
Thames and Hudson, 1997.
*Hans Richter by Hans Richter.* Ed. Brian
O'Doherty. New York: Byron Gallery/
Finch College Museum of Art/
Contemporary Wing, 1968.

**Erik Satie (1866–1925)**
*Écrits.* Ed. Ornella Volta. Paris: Champ
Libre, 1977, 1981.
*A Mammal's Notebook: Collected Writings
of Erik Satie.* Trans. Anthony Melville.
London: Serpent's Tail, 1997.
Volta, Ornella. *Erik Satie.* Trans. Simon
Pleasance. Paris: Hazan, 1997.

**Kurt Schwitters (1887–1948)**
*Anna Blume. Poems.* Paris: Champ Libre, 1994.
Elderfield, John. *Kurt Schwitters.* New York
and London: Thames and Hudson, 1985.
Gamard, Elizabeth Burns. *Kurt Schwitters'
Merzbau: The Cathedral of Erotic Miseries.*
*Kurt Schwitters, Merz: A Total Vision of the
World.* Basel: Museum Tinguely, 2004;
Princeton: Princeton Architectural Press,
2000.
*Merz, écrits choisis.* CD of l'Ursonate spoken
by the author in 1932. Ed. Marc Dachy and
Corinne Graber. Paris: Champ Libre/
Gérard Lebovici, 1990.
*PPPPPP.* Trans. Jerome Rothenberg and
Pierre Joris. Boston: Exact Change, 2001.
Schmalenbach, Werner. *Kurt Schwitters.*
New York: Harry N. Abrams, 1967.

**Walter Serner (1889–1942)**
*Blago Bung, Blago Bung, Bosso Fataka!
First Texts of German Dada by Hugo Ball,
Richard Huelsenbeck, Walter Serner.*
Trans. Malcolm Green. London: Atlas
Press, 1995

**Philippe Soupault (1897–1990)**
Aspley, Keith. *The Life and Works of
Surrealist Philippe Soupault: Parallel
Lives.* Edwin Mellen Press. 2001.
*I'm Lying: Selected Translations of Philippe
Soupault.* Trans. Paulette Schmidt. Lost
Roads Publishers, 1985.
*Last Nights of Paris.* Trans. William Carlos
Williams. Boston: Exact Change, 1993.
*The Magnetic Fields* (with André Breton).
Trans. David Gascoyne. London: Serpent's
Tail, 3rd rev. ed., 1994.
*Profils perdus.* Mercure de France, 1963.

**Sophie Taeuber-Arp (1889–1943)**
Lanchner, Carolyn. *Sophie Taeuber-Arp.*
New York: Museum of Modern Art, 1981.
*Sophie Taeuber-Arp.* Paris: Musée d'Art
moderne de la Ville de Paris, 1989.

**Tristan Tzara (1896–1963)**
Dachy, Marc. *Tristan Tzara Dompteur des
Acrobates. Dada Zürich.* L'Echoppe, 1992.
*Kheperu, or Poems from Tristan Tzara's Hat.*
Blue Night Press, 1999.
*De Nos oiseaux.* (Facsimile of the Simon Kra
edition [1923]). La Bibliothèque des
introuvables, 2004.
Peterson, Elmer. *Tristan Tzara: Dada and
Surrationalist Theorist.* New Brunswick,
N.J.: Rutgers University Press, 1971.
*La Rencontre Sonia Delaunay—Tristan
Tzara.* Musée d'Art moderne de la Ville de
Paris, 1977.
*Seven Dada Manifestoes and Lampisteries.*
Trans. Barbara Wright. Calder Publications,
1981.
*Works by Tristan Tzara, Rainer Maria Rilke,
Jean-Pierre Duprey, and Habib Tengour.*
Trans. Pierre Joris. Inconundrum Press,
2003.

**Facsimile reprints**
*Action.* (1920–1922). J.-M. Place, 1999.
*Ça ira!* (1920–1923). Brussels: J. Antoine, 1973.
*Dada Zeitschriften.* (1918–1921). Hamburg:
Nautilus, 1978.
*Dada Almanach.* (1920). Paris: Champ Libre,
1980.
*Dada. Cabaret Voltaire. Der Zeltweg. Le
cœur à barbe* (1916–1922). J.-M. Place, 1981.
*De Stijl.* (1917–1932). Amsterdam. Athenaeum/
The Hague: Bert Bakker/Amsterdam:
Polak & Van Gennep, 1968.
*Littérature.* (1919–1921 and 1922–1924).
J.-M. Place, 1978.
*Maintenant.* (1912–1915). J.-M. Place, 1977.
*Manomètre.* (1922–1928). J.-M. Place, 1977.

*Mavo.* (1924–1925). Tokyo: Nihon Kindai bungaku-kan, 1991.

*Mécano.* (1922–1923). Vaduz: Quarto, 1979.

*Merz.* (Four 1923 issues). Mouvement Art Libre, 1998.

*The Next Call.* (1923–1926). Utrecht: Reflex/Galerie Gamma, 1978.

*Nord-Sud.* (1917–1918). J.-M. Place, 1980.

*Sic.* (1916–1919). J.-M. Place, 1980.

*75HP.* (October 1924). J.-M. Place, 1993.

*391.* (1917–1924). Antwerp: Ronny van de Velde, 1993.

*Ultra.* (1921–1922). Madrid: Visor, 1993.

## Critical Works

Ades, Dawn. *Photomontage.* Rev. ed., London: Thames and Hudson, 1986.

Balken, Debra Bricker and Jay Bochner. *Debating American Modernism: Stieglitz, Duchamp and the New York Avant-Garde.* New York: American Federation of Arts, 2003.

Dachy, Marc. *Dada Movement.* New York: Rizzoli, 1990.

Dachy, Marc. *Archives du Mouvement Dada.* Paris: Hazan, 2005.

*Documents Dada.* Ed. Yves Poupard-Lieussou and Michel Sanouillet. Geneva: Weber, 1974.

Erickson, John. *Dada: Performance, Poetry, and Art.* G. K. Hall, 1984.

Gales, Matthew. *Dada and Surrealism.* London: Phaidon Press, 1997.

Gordon, Mel. *Dada Performance.* PSJ Publications, 1987.

Hapgood, Susan. *Neo-Dada: Redefining Art 1958–1962.* American Federation of Arts/New York: Universe Publishing, 1995.

Hopkins, David. *Dada and Surrealism: A Very Short Introduction.* Oxford University Press. 2004.

Hugnet, Georges. *L'Aventure Dada (1916–1922).* Intro. Tristan Tzara. Galerie de l'Institut, 1957. Paris: Seghers, 1971.

Naumann, Francis M., *New York Dada: 1915–1923.* New York. Harry N. Abrams, 1994.

Lemoine, Serge. *Dada.* Universe, 1987.

Melzer, Annabelle. *Dada and Surrealist Performance.* Reprint Baltimore: Johns Hopkins University Press, 1994.

Motherwell, Robert. *The Dada Painters and Poets.* Reprint Belknap Press, 1989.

Schippers, Karel. *Holland Dada.* Amsterdam: Querido, 2000.

Sellin, Eric. *Reflections on the Aesthetics of Futurism. Dadaism. and Surrealism: A Parody Beyond Words.* Edwin Mellen Press. 1993.

Shirakawa, Yoshio. *Dada in Japan 1920–1970.* Tokyo: Suiseisha, 2005.

Tashjian, Dickran. *Skyscraper Primitives: Dada and the American Avant-Garde 1910–1925.* Middletown, Conn.: Wesleyan University Press, 1975.

## Exhibition Catalogues

*Dada/Constructivism.* London. Annely Juda. 1984.

*Dada in Zurich.* Kunsthaus Zurich; Arche, 1985.

*Dada and Constructivism.* Tokyo, 1988.

*Dada 1916–1925.* Kunsthaus Zurich, 1993.

*Dada Global.* Kunsthaus Zurich, 1994.

*Making Mischief: Dada Invades New York.* Whitney Museum of American Art, New York: Harry N. Abrams, 1996.

## ILLUSTRATIONS

# INDEX

## PHOTOGRAPH CREDITS

# ACKNOWLEDGMENTS

The author would like to thank l'AFAA (Ministry of Foreign Affairs), Soizic Audouard, Timothy Baum, Jacques Bekaert, Laurence Bertrand Dorléac, The Museum of Modern Art library, Jean-Luc Bitton, Bernard Blistène, Marc Blondeau, le Centre national du Livre: Champ Libre, François Chapon, Mayuko Dachy, Paul Destribats, Elein Fleiss (The Purple Journal), Fondation Arp (Meudon), Fondation Spes, Monique Fong, Patrice Forest (IDEM), Corinne Graber, Dr. Claude Gubler, Mark Kelman, Librairie Tschann, Yves Mabin, Sylvain Perlstein, Paule Pousseele, Marion Sauvaire, Nakao Shimamura, Christophe Tzara, Lorenzo Valentin-Lebovici, Jean Vassallo Paleologo, Claude Weil-Seigeot, Jean-Claude Zylberstein. Editions Gallimard thanks the Archives Luna-Park, Editions Albert Skira, Étude Calmels Cohen, Galerie 1900–2000 (Marcel Fleiss), Luna-Park, Martin Muller (Modernism Gallery, San Francisco), Ronny van de Velde, as well as Editions du Centre Pompidou, especially Annie Pérez, director, Matthias Battestini, and Benoît Collier.

**Marc Dachy** discovered some unpublished works by Clément Pansaers, and at the age of nineteen he set up the publishing company Transédition (1972), which is still in existence today. He started the journal *Luna-Park* (Prix des Créateurs 1978); he also edited Pansaers (*Bar Nicanor*) in 1986, and Kurt Schwitters (*Merz*) in 1990. His *Journal du Mouvement Dada* (1989) was awarded the Grand Prix du Livre d'Art in 1990. He has also edited Aragon's *Projet d'histoire littéraire contemporaine* (1994) and translated John Cage, Gertrude Stein, and La Monte Young into French. An award winner at the Villa Kujoyama in 2000, he wrote *Dada au Japon* (2002). Dachy was also the director of the Lyons contemporary art biennial in 1993 and contributed to *Poésure et Peintrie / Poeting and Paintry* (Marseilles, 1993). In 2005 he organized the *Murayama / Schwitters* exhibition in Tokyo and published the *Archives du Mouvement Dada*. He is currently working on a volume *Dada / Néo Dada* and an exhibition on Tristan Tzara.

*For Kikuko*

English translation: Liz Nash
Editor, English-language edition: Mary Christian
Design coordinator, English-language edition: Christine Knorr
Cover designer, English-language edition: Jonathan Sainsbury

Library of Congress Cataloging-in-Publication Data

Dachy, Marc.
  Dada : the revolt of art / By Marc Dachy.
    p. cm. -- (Discoveries)
  ISBN 0-8109-9255-8 (pbk.)
    1. Dadaism. 2. Arts, Modern--20th century.    I. Title. II. Series.
  NX456.5.D3D318 2006
  709'.04062--dc22

2005030388

Printed and bound in Italy by Editoriale Lloyd, Trieste

10 9 8 7 6 5 4 3 2 1

This work was produced with the help of Editions du Centre Pompidou to coincide with the exhibition *Dada*.